Landscape
Wallcoverings

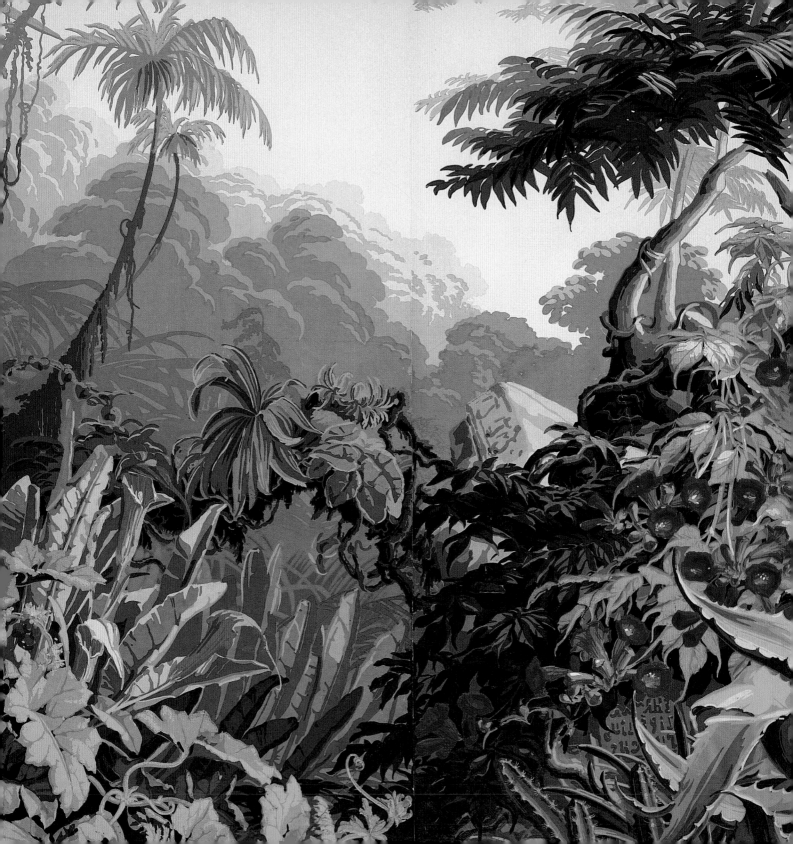

Landscape Wallcoverings

JOANNE KOSUDA-WARNER

WITH ELIZABETH JOHNSON, EDITOR

Scala Publishers
In association with
Cooper-Hewitt, National Design Museum
Smithsonian Institution

Smithsonian
Cooper-Hewitt, National Design Museum

First published in 2001 by
Scala Publishers Ltd
Gloucester Mansions
Fourth Floor
140a Shaftesbury Avenue
London
WC2H 8HD

In association with
Cooper-Hewitt, National Design Museum
Smithsonian Institution
2 East 91st Street
New York, NY 10128

ISBN 1 85759 239 5

Library of Congress Cataloging-in-Publication Data

Kosuda-Warner, Joanne
Landscape wallcoverings / Joanne Kosuda-Warner; with Elizabeth
Johnson, editor
 p. cm
ISBN 1-85759-239-5
1. Wallpaper—New York (State)—New York—Catalogs. 2. Cooper-
Hewitt, National Design Museum—Catalogs. 3. Wallpaper—
History. 4. Landscape in Art. I. Johnson Elizabeth. II. Title.
NK3400 K68 2001
747'.3'0747471–dc21
 00-011686

This publication has been made possible, in part, by the Andrew W.
Mellon Foundation Endowment.

Notes Regarding the Illustrations
All wallcoverings illustrated in this volume, unless otherwise
noted, are part of the collection of Cooper-Hewitt, National Design
Museum, Smithsonian Institution.

Dimensions given in the captions are height by width and indicate
the size of the object shown.

Designed by Anikst Design, London
Produced by Scala Publishers Limited
Printed and bound in Italy
Photographs edited by Jill Bloomer
Photographs, except where noted, by Matt Flynn

page 2: Detail of *El Dorado*, France, 1849, printed by Zuber et Cie,
copyright © Zuber et Cie (fig. 34)

page 6: Detail of *May Tree*, England, 1896, designed by
Walter Crane (fig. 61)

page 112: Detail of tree-framed scene, Hanover, Pennsylvania,
1945–58 (fig. 78)

Contents

Preface

There is a story, almost certainly apocryphal, that Gustave Flaubert found the rigors of traveling so exhausting that he claimed he preferred to see the world from a couch while paintings of scenery were unfurled before him. Flaubert would have been delighted by a genre of wallpaper that seems to fulfill his taste for a luxurious, passive form of tourism.

Cooper-Hewitt, National Design Museum has an entire curatorial division devoted to wallcoverings. Indeed, with more than 10,000 papers, it is the largest such collection in the nation. Within resides a fantastic body of papers that take landscape as their theme, some of which, in effect, become complete indoor landscapes. These panoramic papers—created to transform the walls of a room with 360-degree views—are the apogee of landscape wallpapers and the centerpiece of this publication.

In *Landscape Wallcoverings*, Joanne Kosuda-Warner, Assistant Curator for Wallcoverings, traces the origins of wallpaper. Her richly illustrated narrative, written with the Museum's editor Elizabeth Johnson, tells how landscape representation evolved into its own artistic genre and traveled from canvases and looms to the papered panels that have turned domestic interiors inside out since the eighteenth century. The wallpapers seen here reflect cultural tourism, colonial acquisition, national pride, and pastoral myth, while testifying to technical innovation and artistic virtuosity.

With more than 250,000 objects in four curatorial areas—Applied Arts and Industrial Design, Drawings and Prints, Textiles, and Wallcoverings—as well as a vast library, the collections of Cooper-Hewitt are full of artifacts with intrinsic aesthetic properties and extrinsic social meaning. We are delighted that our collections can shed some historical perspective on our cultural attitudes and the landscape with such exuberance and beauty.

Susan Yelavich,
Assistant Director for Public Programs

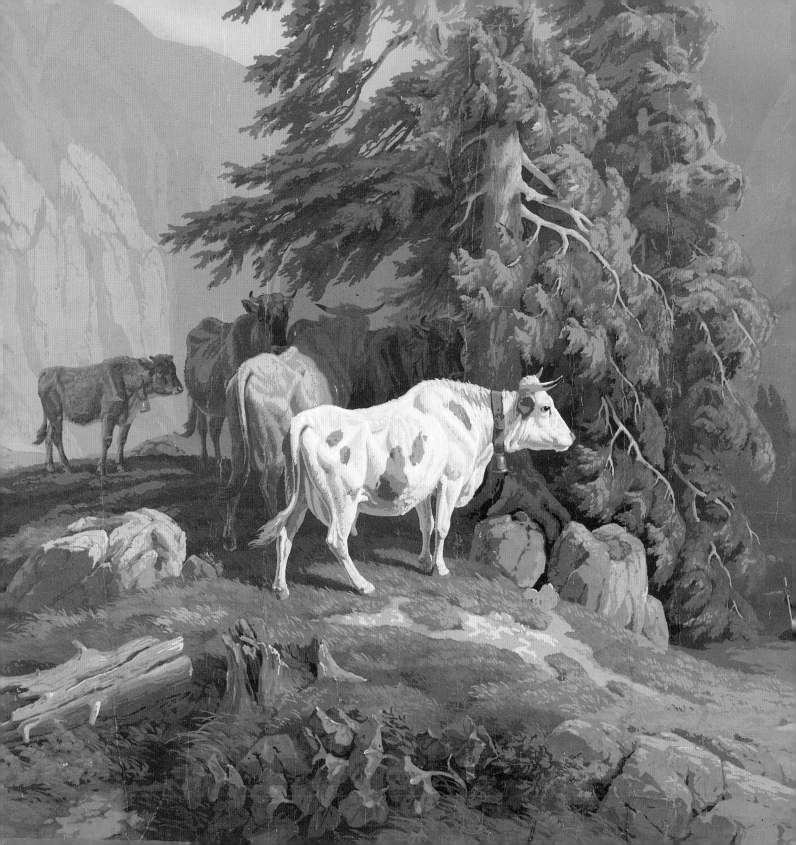

Introduction

The histories of landscape painting and wallpaper overlap from their modern origins in the sixteenth century through today and reflect changing social attitudes toward nature and their transmission—first through art and later through industry. In the early 1500s, paintings of nature were given a name in many Western languages—in English, the term *landscape* was introduced; in Germany, it was *landschaft*, and in Italy, *paese*. The first printed papers found on interior walls, in England, date to the same period. It is quite appropriate, therefore, that representations of nature, which were becoming more common in the fine arts, appear on early wallpapers and developments in landscape representation are reflected in wallpapers throughout the last three centuries.

For hundreds of years, European homeowners had decorated their walls with various textiles for both warmth and aesthetics. They hung linens, brocades, damasks, and tapestries. The heavy, woven tapestries, which originated in the thirteenth century, often depicted narrative scenes. It was these textiles that first brought landscapes indoors in the modern period, and they would later be drawn upon as a source of inspiration for paper wallcoverings. In fact, in the late eighteenth century, Jean-Baptiste Réveillon, one of France's most important wallpaper manufacturers, employed designers from the Gobelins tapestry factory.

Wallpaper is reflective of both popular and elite aesthetic tastes. Through its history, the form dramatically reflects trends in fine art, popular culture, and technological innovation. The interpretations of landscape that have made their way onto wallpapers reflect the intellectual trends that gained the widest currency. This book documents the changing attitudes in Europe and the United States toward nature—from romantic naturalism to modern abstraction—through the depiction of landscape on wallpapers produced during the eighteenth, nineteenth, and twentieth centuries.

Opposite

Detail of figure 47

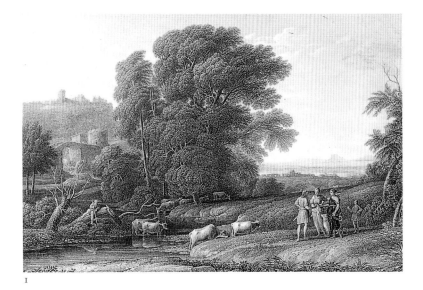

I

A Brief History of Landscape Painting

The urge to bring nature indoors dates to ancient times. Roman painters executed landscapes on interior walls to extend the visual space of rooms. These paintings often reflected the prevailing landscape theory of the age. Descriptions of the landscape that came to be known as "pastoral" first appeared in the poetry of ancient Greece and Rome, most notably in Virgil's *Eclogues*, ten poems also known as *Bucolica*, composed between 42 and 37 B.C. Virgil's poems—and the pastoral genre—describe the idyllic world of Arcadia in which shepherds tend their flocks and lead simple lives closely attuned to nature. Pastoral landscapes, which recur in painting and on wallpapers throughout the centuries, depict simple, rustic settings with farm animals grazing or peasants working the land.

During the Middle Ages, landscape—as the setting for human and divine stories—was relegated to the background rather than the subject of paintings. In the sixteenth century, however, landscape painting enjoyed a renaissance, particularly in Italy and the Netherlands. In Venice, Giorgione's and Titian's works reflect the century's two most popular styles of landscape—the heroic and the pastoral. The heroic landscape, represented in Giorgione's *The Tempest* (ca. 1505), shows nature in an idealized form, punctuated with classical architectural structures. Titian's paintings present the pastoral countryside.

At the same time, Dutch painters were becoming interested in a realis-

tic depiction of landscape. As part of the burgeoning Dutch and Flemish tradition of genre painting, or paintings of everyday activities, Pieter Brueghel the Elder presented nature as closely intertwined with daily life. In *The Return of the Hunters*, from a series of paintings of the months done in 1565, Brueghel inverted the balance between figures and nature so that nature became the primary subject of the painting.

In the mid-seventeenth century, Claude Lorrain (1600–1682), a French painter active in Rome, began to paint a new kind of landscape (fig. 1). His unprecedented naturalism and attention to the effects of natural light elevated the ideal-landscape genre. Most of Claude's paintings done in the 1630s and 1640s epitomize a new pastoral ideal, depicting a utopian view framed by trees, a crisply defined middle ground, and distant bridges or towns painted in soft tones.

From Canvas to Paper

All of these painterly approaches to depictions of landscape made their way onto wallpapers, as did approaches that arose from more popular sources. In many ways, the story of landscape wallpaper is also a history of tourism. The travel industry—restricted to the upper classes in the eighteenth century, but broadening considerably in the nineteenth with the invention of the steamboat and railroad—created the desire to visit exotic places and bring back souvenirs. Wallpaper renderings of distant places served both those who traveled and those who only dreamed of it.

This book includes examples of wallcoverings from the eighteenth through the twentieth centuries, but focuses on the nineteenth, when interest in landscape and landscape study reached new heights and, simultaneously, wallpaper manufacture changed from a labor-intensive craft to industrial mass-production. Through more than eighty examples, including breathtaking room-size panoramic papers, this book investigates the perennial fascination with landscape themes and how they were translated into both luxurious and everyday wall decoration.

The wallpapers illustrated and discussed here are, with few exceptions, from the permanent collection of Cooper-Hewitt, National Design Museum, Smithsonian Institution, in New York City, which houses the largest collection of wallpaper in the United States. They provide a glorious opportunity to see the world as it's been imaginatively interpreted for the decoration of our private sanctuary—the home.

Chapter One

Origins, 1650–1800

In the early sixteenth century, as paper became less expensive, Europeans began to paste papers printed with images and decorative patterns on their walls. Paper decorated with a textile design found on beams in a building at Cambridge University in England dates to around 1509. At roughly the same time, a French craftsmen's guild called the *dominotiers* was producing single sheets of decorated papers, referred to as *domino*, for a middle-class market. These papers, which remained in production for hundreds of years, were simply designed and printed, usually with a heavy black outline filled in with thin color using stencils (fig. 2). From the beginning, floral and other natural motifs were common subjects. *Dominos* had many uses: as lining for furniture, as endpapers for books, and, when joined with other sheets, as wallcoverings. Colorful and inexpensive, *dominos* were very popular in France, and similar papers were produced in the Netherlands, Italy, England, and Germany. The subject of these simple papers would eventually encompass full landscape renderings.

A late seventeenth-century English paper printed in the *domino* technique may be the earliest example of a landscape to appear on wallpaper (fig. 3). It depicts a stag hunt—a traditional aristocratic pastime—in a parklike setting. The outdoor setting and distinctive trees in the background connect the paper stylistically to fragments of wallpaper in three other collections, suggesting that they may have been part of a set. Taken together, these pieces, which date from about 1680 to 1700, form a panoramic view of a landscape. The Victoria & Albert Museum's collection, in London, contains a companion piece depicting a woman fishing; a fragment in Colonial Williamsburg's collection, in Virginia, contains a figure walking down a hill toward a large house; and a piece in a private collection depicts a well-dressed woman near a fountain in a park.

The paper's origins are unknown, but according to Charles Oman and

Opposite

Detail of figure 17

2

2

Domino paper
France, 1735–50
Block printed and stenciled
45 × 35 cm
Gift of Eleanor and Sarah Hewitt,
1928–2–77

3

Fragment of wallpaper showing a
hunting scene
Late 17th century
Block printed and stenciled
Courtesy Whitworth Art Gallery,
University of Manchester, England

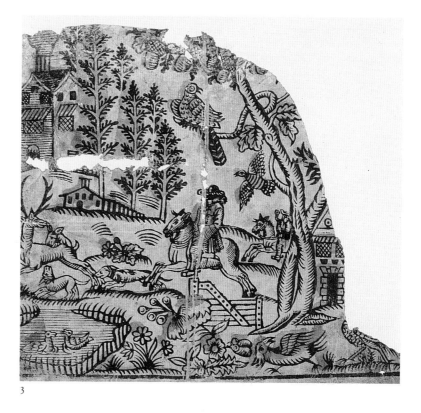

3

Jean Hamilton, "There is obviously a common source, perhaps a painted cloth hanging, for all scenes, which may have been intended to be shown in conjunction with one another" (Oman and Hamilton, *Wallpapers: An International History and Illustrated Survey*, p. 98). Such a painted cloth hanging, usually linen or other strong cloth stretched on a frame, may have been based on an even earlier tapestry. Tapestries commonly depicted leisure pursuits of the aristocracy, and papers such as this stag hunt demonstrate the popularity among the middle class of imagery previously available only to an exclusive audience.

The Early Eighteenth Century

Simple *domino*-type papers remained popular throughout the seventeenth century, as advancements were slowly made in printing. By the early eighteenth century, wallpaper production was becoming more industrialized, particularly in England, which, unlike France, was not limited by a restrictive guild system. Continuous rolls formed by gluing

4

together single sheets were replacing small individual sheets, and a standard roll length of twelve yards was established among English manufacturers, followed in short succession by the creation of conventional retail outlets for this new commodity. An early advertisement for wallpaper dates to about 1720. London manufacturer Abraham Price advertised his Blue Paper Warehouse as carrying the most fashionable paper hangings. His prosperous showroom, full of patterned paper, is depicted on a handbill that declares, "The Original Manufacture Warehouse: Abraham Price makes and sells the true sorts of Figured Paper Hangings Wholesale and retail, in pieces of twelve yards long; in imitation of Irish Stitch, Flowered Sprigs and Branches, Others Yard-wide in imitation of marble, and other colored wainscots fit for the hangings of parlors, dining rooms and staircases. . . . All of which are distinguished from any pretenders by these words at the end of each piece The Blue Paper Manufacture" (Lynn, *Wallpaper in America: From the Seventeenth Century to World War I*, p. 29). Price clearly appeals to the luxury end of the market with his choice of words—"distinguished from any pretenders"—and images, which depict well-heeled clients choosing wallpaper, including those of "flowered sprigs and branches."

The new increase in production had the potential to create more papers than English customers alone could buy, and new markets were created in the American colonies. In 1712, Queen Anne of England imposed a tax on all wallpapers not intended for export, creating an impetus for English manufacturers to market their papers in France and the New World.

As printing techniques became more sophisticated, mass-market papers filled with "aristocratic" imagery became more refined. French wallpaper historians have informally termed papers like the hunt scene shown here (fig. 4) "tapestry" papers after their affinity to their woven predecessors. Like tapestries, these papers sometimes had borders on all sides to frame the image. This example is composed of eight separate sheets of paper that were joined on the wall. This group of sheets is incomplete, however, and it is unknown if the design was larger than what is shown here. Similar examples in French and Swiss collections depict repeating landscape scenes.

Early papers such as this tapestry paper were printed with woodblocks. By mid-century, wallpaper manufacturers had refined block printing to the point where they were using one block—instead of a stencil—to print each color. This refinement required a more labor-intensive production process, but it greatly improved the finished quality of images on papers.

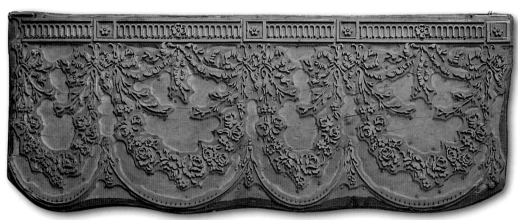

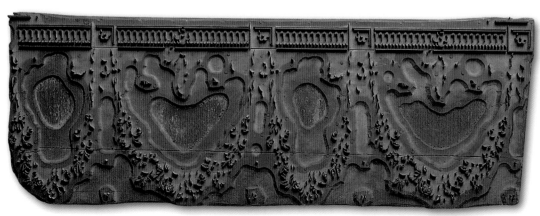

5

Woodblocks—like the ones shown here (fig. 5), which date from a century later—were carved for each color that would be used in the paper. One block was inked and printed on the entire length of paper, the paper was allowed to dry, and then the next block was inked and printed. This process continued until all colors and blocks had been printed. Simple, less expensive papers could still be printed with few blocks, while ever more elaborate designs were developed for the luxury market.

Chinese Wallpaper

In the eighteenth century, the most complex and spectacular landscape wallpapers, in both Europe and the American colonies, came from China. All kinds of objects from the Orient were in vogue at that time. The Chinese had been trading with Europe through the East India trading companies since 1599 when the British East India Company was founded (other European countries set up their own trading companies shortly thereafter), and these traders brought back the first Chinese papers, beginning in the 1690s. (They were sometimes called "India" or "Japan" papers, which created confusion about their origin.) Since Chinese homes did not include patterned or painted wallpaper, it is believed that painted sets of wallpaper were first created by Chinese merchants to give as gifts to finalize deals with their European trading partners.

In great contrast to their European counterparts, which were typically modest in scale and crudely printed, the Chinese samples were masterfully hand-painted, not printed, using many hues of water-based gouache or tempera to create a luminous quality (fig. 6). In addition, they were conceived on a grand scale; up to forty panels formed a set, which when hung formed a continuous, nonrepeating panorama within a room. The fresh color, spontaneous brushwork, and scenic nature of Chinese papers, along with the enormous appeal of all things Chinese, made them a coveted product throughout the eighteenth century. Scholars credit the quality of Chinese papers as an impetus for improved quality in the European industry.

Chinese wallpaper subjects can be divided into three broad categories: those with a flowering tree and fantastical rocks and birds; those with a flowering tree and people; and those with Chinese people supposedly going about their daily lives in a landscape setting. This last category was especially sought after because the interior of China was still closed to Westerners throughout the eighteenth century. European traders conducted their business at coastal stations and recorded only brief glimpses

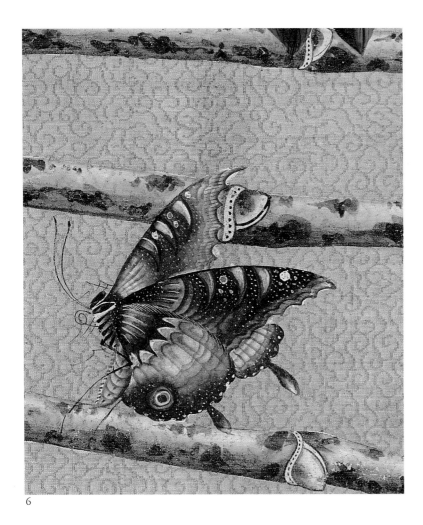

6

of Chinese life. Westerners often imagined an exotic land of silks, porcelains, jades, and tea, where peonies grew to perfection and pagodas stood on every corner. Most important, the Chinese were perceived to live in harmony with nature.

In the examples of Chinese wallpapers shown here (figs. 7, 8), scenes of daily life are depicted in dense, detailed landscapes. In both examples, landscape features are depicted in a stylized fashion, with depth conveyed by a flattened perspective, while many beautifully painted details animate the scenes. In this way, the papers resemble earlier European tapestries, which also used a flat plane embellished with intricate details to excellent

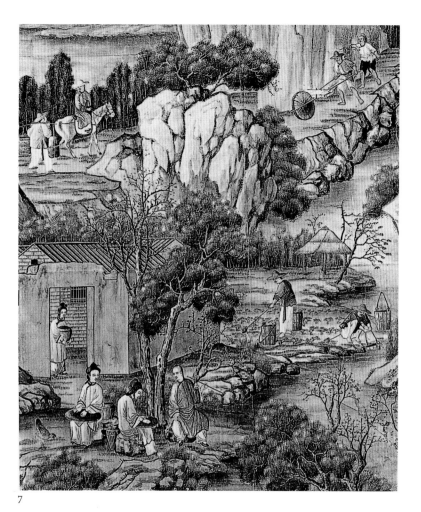

7

effect. Figure 8 affords a rare chance to see the original colors in an eight-
eenth-century paper. Purchased in 1784 for one hundred dollars by Robert
Morris of Philadelphia, the paper wasn't hung until 1924, which explains
its vivid color today.

By the middle of the eighteenth century, demand for Chinese hand-
painted papers was strong enough to prompt French and English manu-
facturers to produce their own imitations in a repeating format. These
papers are filled with Chinese scenes interpreted in a distinctly Western
mode. As in other decorative and fine arts, objects produced in this fash-
ion are known as "chinoiserie." Designers of chinoiserie wallpapers

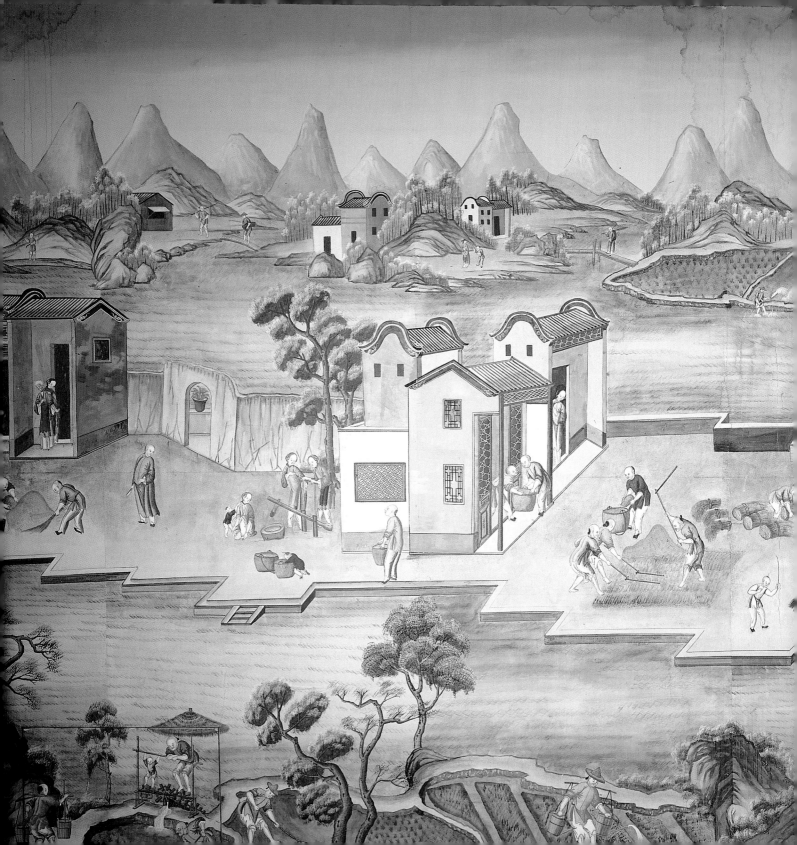

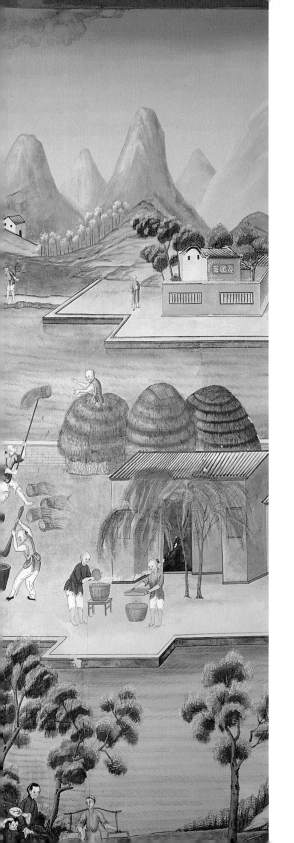

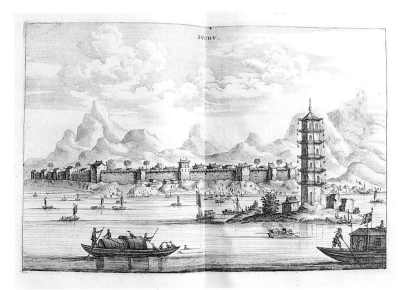

9

looked, of course, at the papers that had been brought back from Asia, but they also referred to illustrated travel books. One of the earliest sources to include Chinese imagery was *Atlas Chinensis* by Johannes Nieuhof, published in Amsterdam in 1655 (fig. 9). It contained written descriptions as well as engravings of the people, buildings, and landscapes that Nieuhof encountered while traveling in China. In 1688, two Englishmen, John Stalker and George Parker, published the influential *Treatise of Japanning and Varnishing*, which included engraved plates of rare Chinese lacquered furniture decorated with images of pagodas, hilly landscapes, birds, flowers, and people. These images, many derived from Nieuhof, were used to decorate ceramics, fabrics, furniture, and other objects, including wallpaper.

One of the most successful chinoiserie designers was Frenchman Jean-Baptiste Pillement (c. 1727–1808). His delicate and fanciful chinoiserie was widely used by the producers of decorative objects. Shown here is a French example of about 1780 based on a Pillement design (fig. 10). The incongruous pairing of a shepherdess guarding her flock and the curious combat scene typifies the playfulness and exotic charm of this genre. The compositional convention of "floating" scenes, used here and in subsequent papers, is first encountered in European silk designs of the 1730s.

10

Classical Landscapes

In 1744, John Baptist Jackson (c. 1700–1777), an English wood-engraver, introduced to wallpaper the heroic landscape—a view that includes monumental objects from art and nature—which was making a resurgence among some Italian painters. His nonrepeating paper, *Heroic Landscape with Fishermen, Cows, and Horsemen*, after his contemporary, the Venetian landscape painter Marco Ricci, was one of Jackson's attempts to elevate the treatment of landscape subjects on wallpaper by connecting it to classical history and the fine arts (fig. 11).

10

Chinoiserie depicting shepherdess and aerial combat
France, c. 1785
J. B. Réveillon
Block printed
61.5 × 51.5 cm
Gift of the Museum at The Fashion Institute of Technology,
1998–75–92

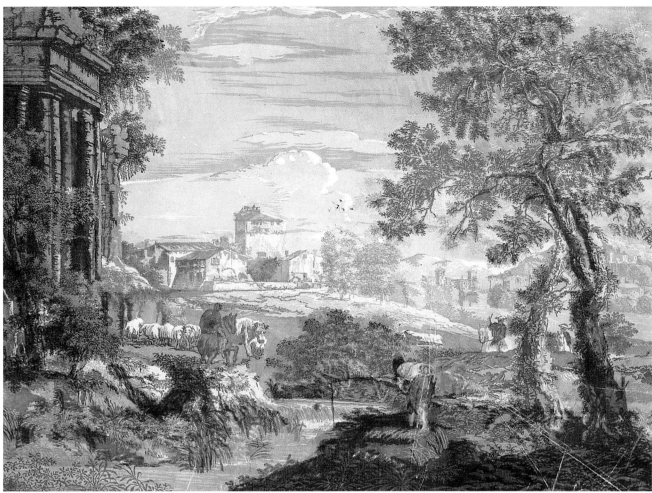

II

Jackson's classical landscape papers were offered as a direct alternative to the Chinese-style papers that had become so popular. In a 1754 book, *An Essay on the Invention of Engraving and Printing in Chiaroscuro*, Jackson clearly stated his intention to replace Chinese subjects with his own, which would use softer colors and subjects drawn from antiquity and the landscape paintings of Claude Lorrain, Salvator Rosa, Nicolas Poussin, and Giovanni Paolo Pannini. The wallpaper market, however, did not support Jackson's innovations, and he went out of business in 1755.

Just a few years later, Jackson's favored subject matter came into vogue,

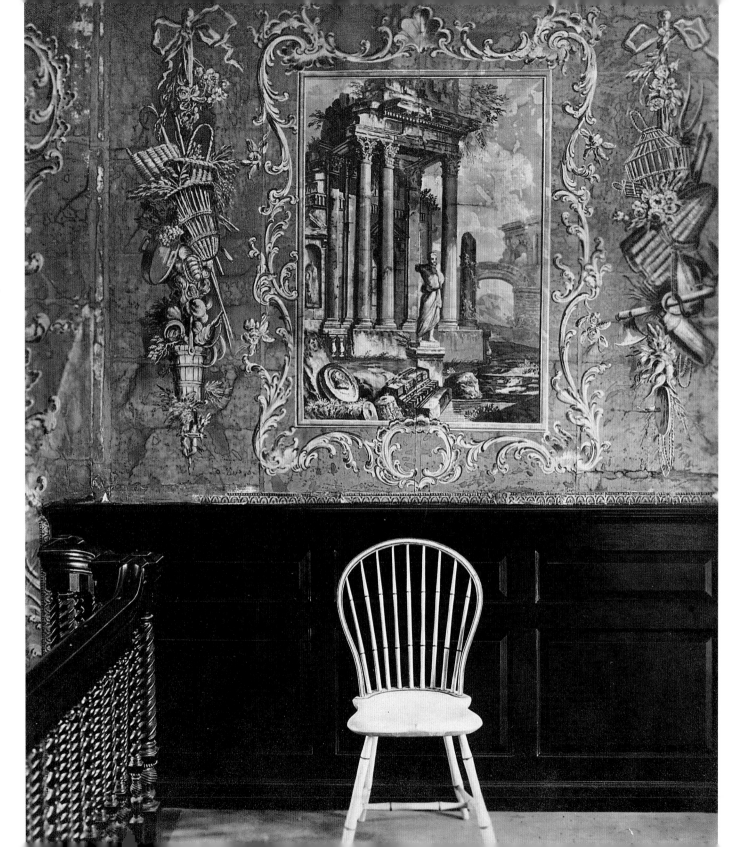

13

and hand-painted wallpapers based on the paintings of Pannini were pro-
duced in London. In a photograph of the Jeremiah Lee Mansion in
Marblehead, Massachusetts, built from 1767 to 1769, one of these papers
is seen *in situ* (fig. 12). Lee, one of the wealthiest men in the colonies, com-
missioned three of these nonrepeating wallpapers from London.
Showing a framed landscape with ancient ruins surrounded by rococo
scrollwork and flanked by pastoral trophies, the paper was intended to
convey up-to-date sophistication, both in familiarity with ancient Rome
and in the appreciation of nature and simple pursuits, represented by the
baskets and farm implements.

 Mass-produced papers that emulate the paper from the Lee Mansion
began to appear during the 1760s. In an English sample set about 1769,
small landscape vignettes, possibly of Italy, are set in delicate scrollwork
frames (fig. 13). Many of the images on these wallpapers were based on

published engravings, which became a valuable source for manufacturers during the eighteenth century. Since the Renaissance, prints had been widely published throughout the Western world, as artists tried to promote their work and governments publicized their countries' buildings and monuments.

This new demand for heroic landscapes can be traced to the Grand Tour. The Grand Tour, which became popular in the seventeenth century and remained so for more than a hundred years, was an extended trip to Paris, Florence, Naples, Venice, and finally Rome, where the educated tourist usually stayed for a period. As more and more people embarked on these tours and the publication of prints made ancient ruins instantly recognizable, the depiction of crumbling monuments of antiquity became more common in all sorts of decorative objects. Moreover, in the 1750s it also became popular to build artificial ruins, often in the form of an archway with columns, a temple, or a colonnade, in outdoor settings. Ruins—artificial and authentic—symbolized the fleeting glory of human civilization and were romanticized and reinterpreted to create a new classical vocabulary for the emergent era of the Enlightenment.

Papers with framed vignettes came to be called "print room" wallpapers, named after the fashion of cutting out printed views and ornaments and gluing them to the wall. An English print room paper in the collection of the Victoria and Albert Museum, from the 1760s, was never hung, so it retains its original vibrant color today (fig. 14). One of the large landscape scenes depicts a temple, but the other scene is derived from the *fête galante,* a type of landscape painting originated by Jean-Antoine Watteau much earlier in the century, and characterized by young lovers in an idealized natural setting. The *fête galante* and the other motifs depicted on this paper can be traced to published engravings. This paper also includes fantastical vegetation, used as a framing and decorative compositional device.

The Late Eighteenth Century

Although French wallpaper producers continued to use the *domino* technique well into the eighteenth century, by the 1770s some were producing technically sophisticated papers with their own approach to landscape themes. A paper produced around 1780 is made up of small vignettes depicting both classical ruins and more commonplace structures (fig. 15). The windmill, hermitage, and a rustic mill may have been drawn from published prints of the landscape garden of Ermenonville, near Chantilly.

14

"Print room" wallpaper
England, c. 1760–65
Block printed
Courtesy Trustees of the Victoria &
Albert Museum

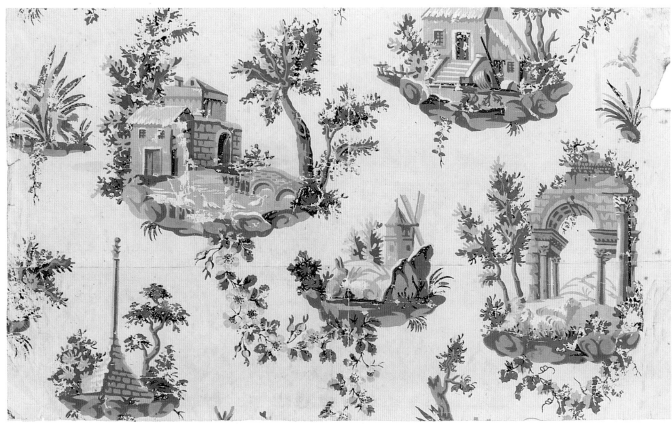

15

One of the most influential French gardens of the eighteenth century, Ermenonville was composed of views made to resemble famous landscape paintings. The paper is less ornate than English print room papers and simpler in its style of illustration. The vignettes are informally scattered and are not framed.

The most distinctive types of French paper throughout the French Revolution period were arabesques, which included vignettes but featured curling foliage, festoons, and figures. Traditional arabesques—distinctive decorative motifs consisting of complex and intricate patterns of interlaced tendrils, bands, scrolls, and leaves—were inspired by the ornamental traditions of the Near East and were popular throughout Europe from the 1500s on. By the 1700s, however, the French had adopted the term *arabesque* to describe any ornament incorporating scrolls,

15

Vignettes of rural scenes and antique ruins
France, c. 1780
Block printed
34 × 59 cm
Gift of Harvey Smith,
1968-III-128

16

Arabesque with small landscape
France, late 18th century
Block printed
39 × 53 cm
Gift of Miss D. Lorraine Yerkes,
1955-89-3

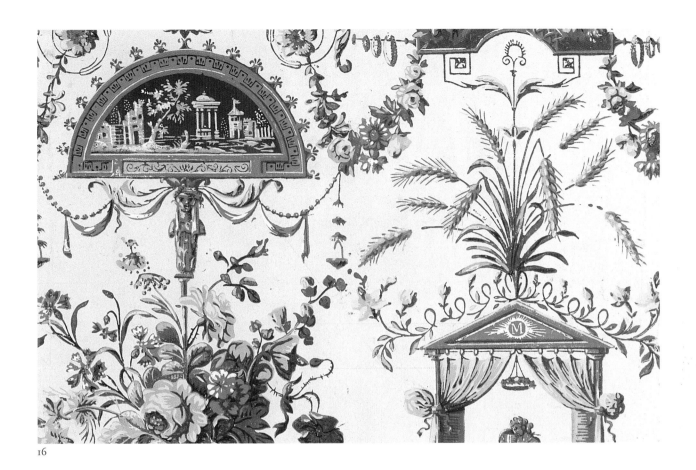

16

foliage, and figural elements arranged in a narrow, vertical manner. This overall vertical orientation, used on ceramics, textiles, and metalwork, was especially useful in wallpaper design. The independent elements of the motif—mythological figures, landscape scenes, urns, festoons, and scrolls—could easily be assembled and stacked to extend a design to the necessary length.

A fragment of an arabesque paper from about 1785 depicts a miniature ancient landscape framed within a lunette (fig. 16). In both their neoclassical subjects and their framework, arabesque papers allude to the ornamented styles made popular with the mid-eighteenth-century discovery of the well- preserved Italian cities of Herculaneum and Pompeii, both of which had been buried in A.D. 79 after the eruption of Mt. Vesuvius. Arabesques intro-duced a wide range of classical ornament including

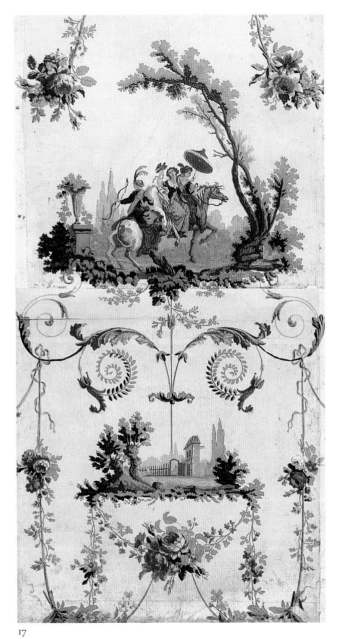

17

18

17

La Chasse au Faucon
France, 1794–97
Block printed
104.0 × 54.5 cm
Gift of Eleanor and Sarah Hewitt,
1931–45–28

18

Wallpaper depicting offering to
Cupid and landscape scene
France, c. 1800
Block printed
129 × 63 cm
Museum purchase from
Smithsonian Institution
Acquisitions Program Fund,
1998–28–1–a

scrolling, foliage, urns, and architectural elements such as an altar surrounded by a temple form.

A paper of 1794–97 is an arabesque of a larger scale, titled *La Chasse au Faucon* (fig. 17). The falcon hunt shown at the top is depicted in the playful manner of the *fête galante*, while the image below suggests the entrance to a park, which had become a new fashion in landscape design.

Neoclassical and pastoral motifs are combined in a French paper from about 1800 (fig. 18). Striped cones form hexagonal frames around an image of three maidens making an offering to Cupid. The framed scene alternates with a less formal vignette of a man relaxing under a tree and contemplating the landscape. Depictions of Cupid became common in the late eighteenth century, inspired by the examples uncovered at Herculaneum and Pompeii, and were often used in decoration to symbolize love.

Regard for the landscape and natural forms would reach its peak in the nineteenth century, with the rise of tourism to natural wonders, the resurgence of landscape painting, and the introduction of panoramic wallpapers, which reproduced images of landscapes on an immense scale.

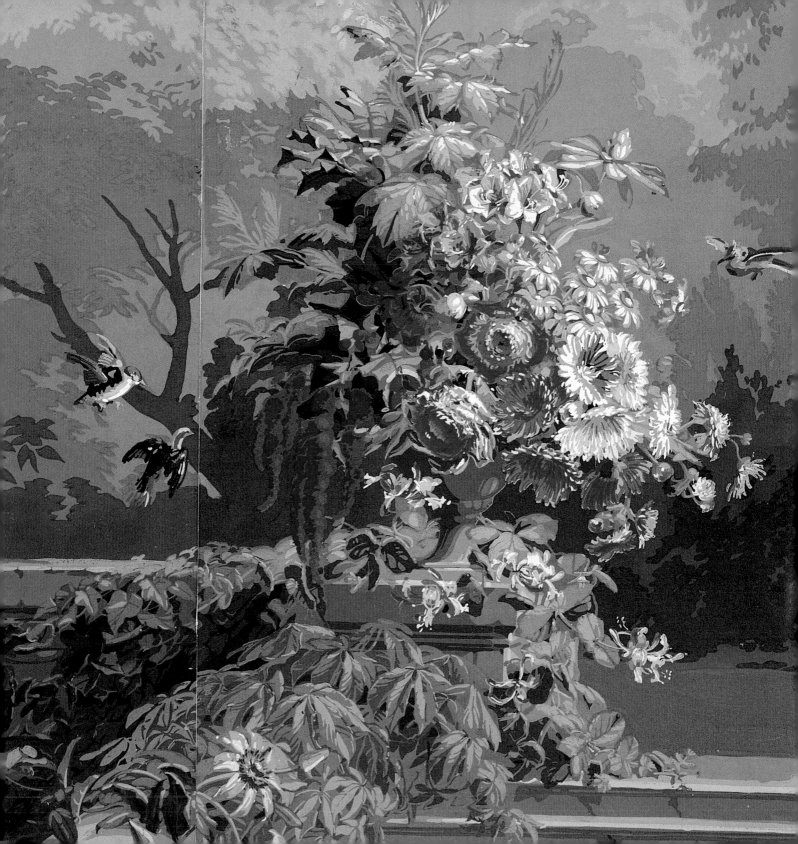

The Scenic Panorama, 1800–1850

RICH PAPER HANGINGS JUST RECEIVED. Sets of Monuments of Paris, a very elegant Hanging. Sets of the River Bosphorus. English Gardens—Capt. Cook's Voyage. Views of Switzerland—Hindustan Scenery. 12 Months, with framing paper and border. The above are in colors and long-strip landscapes. ALSO a set of rich cloth and gilt papers with top and bottom border to match. LIKEWISE, Views in Italy—Water Scenes. Views in Turkey—Roman Scenery. Ports of Bordeaux and Bayonne, Elysian Fields, Grecian Arcadia and many other landscape papers, making as great a variety as can be found at any store in town, and at the lowest prices. . . .

—Advertisement in the *New England Palladium* (Boston), December 2, 1817, by James H. Foster

James Foster's advertisement indicates the most popular wallpaper style in the first part of the nineteenth century: scenic landscape papers. He calls these papers "long-strip landscapes" and "views," but the French manufacturers called them *papier peint panoramique*, or panoramic wallpaper.

The panorama—a broad, continuous view of a landscape—originated as a type of landscape painting in the late eighteenth century. The first panoramic painting was done in 1787 by Robert Barker, an Irishman living in Scotland, who painted a 360-degree view of Edinburgh. Barker's painting, exhibited in a cylindrical room, was greeted enthusiastically and spawned a small industry of imitators.

Panoramic wallpaper, like the painting genre that most likely inspired it, reproduced a complete view of a landscape, which surrounded the viewer when it was applied to the walls of a room or hall. Panoramics opened up large vistas in rooms of any size. Scenics, as these nonrepeating papers were also known, were manufactured exclusively in France

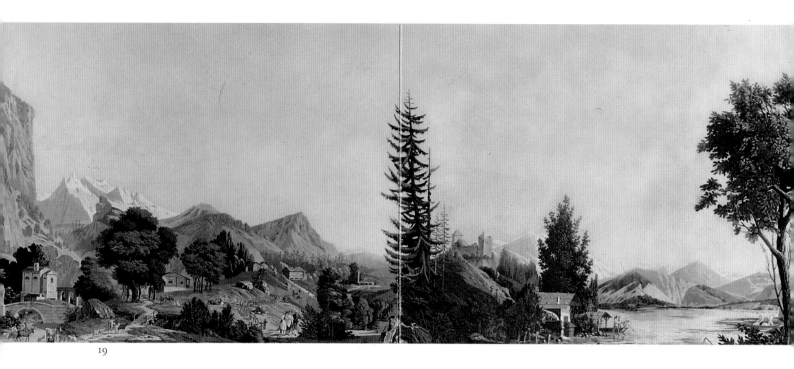

19

but were sold throughout Europe and the United States. These luxury
wallpapers, sets of which are still manufactured today, are astounding in
their scale, coloration, and detail.

The first of its type, *Views of Switzerland*, first printed in 1804, is typical
of panoramic papers in subject, format, and method of production (fig.
19). Tours of Europe continued to grow in popularity during the early
nineteenth century, and "souvenir" imagery was used for a wide variety of
printed material. This paper depicts some of the most visited Swiss
destinations—Staubach Falls, Furka Glacier, the village of Bern, and the
Pont du Diable (Devil's Bridge), among others. Whereas monumental
ruins were popular motifs in the landscape papers of the previous cen-
tury, topography and terrain became more common themes in the nine-
teenth, as adventurous pastimes, such as mountain climbing, took off. At
the same time, viewing natural wonders such as glaciers and waterfalls
became an important part of touring.

Like all panoramic papers, *Views of Switzerland* was block-printed in an
elaborate, labor-intensive process. Designed by Pierre-Antoine Mongin
and printed by Jean Zuber of Rixheim, France, *Switzerland* required 1,024
woodblocks and 95 colors. Panoramic papers were carefully designed so

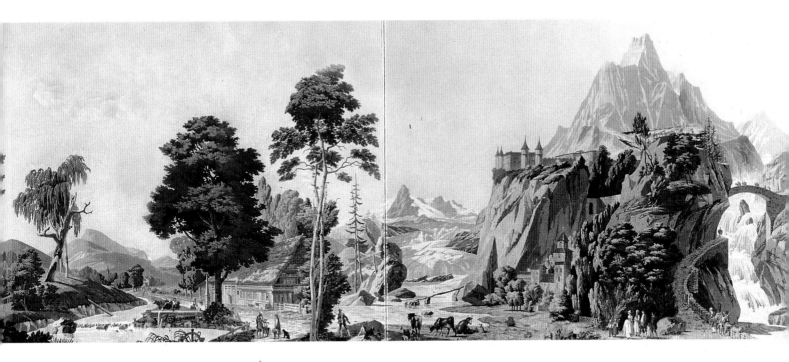

19

Views of Switzerland
Rixheim, France, 1804
Designed by Pierre-Antoine
Mongin
Printed by Jean Zuber
Block printed
Courtesy Carole Thibaut
Pommerantz

that they could be adapted to accommodate rooms of different dimensions. Transitional devices—often rocks or trees—were included but could be left out if necessary to allow for doors and windows.

The sky was an important part of a scenic wallpaper's impact—and adaptability. When the paper was hung, the sky dominated the upper third of the wall, and it could be cut horizontally at any point to accommodate any ceiling height. Because of the sky's prominence, manufacturers developed their own artistic style of rendering them. The Zuber company became known for wonderfully tinted skies, painted by hand with large brushes before the rest of the paper was printed with woodblocks. A pale yellow at the horizon blended into a cloudless, perfect blue that imparted a luminous quality to the room in which it was hung. A rival manufacturer, the Dufour company, favored skies dotted with expressionistic clouds, ranging from fluffy and bright to low and dark.

In addition to exotic "views," subjects for panoramic papers came from mythology, military history, literature, and the pleasures of daily life. To transform a battle scene or mythological story into a view that could fit almost any room was no mean feat. The designers, many of them anonymous, usually worked with popular prints of the story or view that they

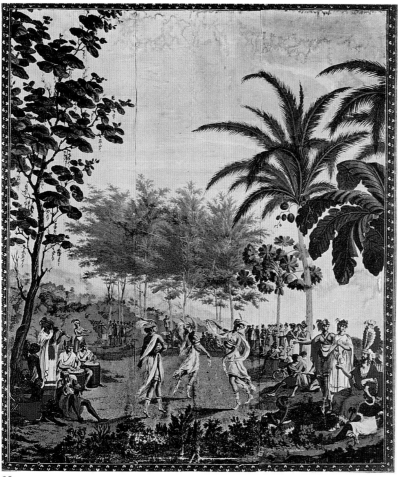

20

20

Sauvages de la mer Pacifique
Macon, France, 1804
Designed by Jean-Gabriel Charvet
Printed by Dufour
Block printed
Plate V from *Les Chefs d'Oeuvre du Papier Peint, Tableaux-Teintures de Dufour & Leroy* (Paris: Librairie des Arts Decoratifs, A. Calavas, Editeur, c. 1930). Cooper-Hewitt, National Design Museum branch, Smithsonian Institution Libraries

wanted to re-create. This helped to ensure that the public would recognize the imagery in the finished paper. Existing engravings or paintings were often used as departure points by designers, who then might combine the images in an original way. A distant view based on a printed image might be superimposed on a foreground created by the designer. Such manipulations were necessary so that each manufacturer had its own unique product, but also so that the narrative depicted could be conveyed within the dimensions of the finished paper, which conformed to a standard room.

A print from *Les Chefs d'Oeuvre du Papier Peint, Tableaux-Teintures de Dufour & Leroy* shows a detail from Joseph Dufour's first panoramic

paper, *Sauvages de la mer Pacifique* (fig. 20). Also known as *Voyages of Captain Cook*, this paper loosely documented the discoveries of British naval captain James Cook, who explored the Pacific in the late eighteenth century. Some of the subjects chosen by manufacturers contained a definite didactic component. Indeed, they often exhibited a nationalistic pride typical of the time, but which would today be viewed as cultural imperialism. Dufour included a pamphlet with the *Sauvages* paper, which revealingly stated: "This decoration has for its object the idea of making the public acquainted with peoples and lands discovered by the latest voyagers, and of creating, by means of new comparisons, a community of taste and enjoyment between those who live in a state of civilization and those who are at the outset of the use of their native intelligence" (Lynn, *Wallpaper in America*, p. 202).

Dufour also makes claims regarding the paper's edifying effects: "The mother of a family will give history and geography lessons to a lively little girl. The several kinds of vegetation can themselves serve as an introduction to the history of plants" (Lynn, *Wallpaper in America*, p. 202). Detailed depictions of plants were frequently placed in the foreground. Often these plants reflected the current public interest in new hybrid forms and plants collected from other parts of the world. Designers known for their skill in botanical illustration were sometimes hired.

Many papers were available from manufacturers in either full-color or less-expensive monochrome. Grisaille (shades of gray meant to imitate carved stone) was the most popular of the single shades, but sets were also printed in sepia, yellow ocher, olive, and blue. Not only economical, single shades were a style in their own right. The range of subject matter for monochrome papers was similar to that available as color sets. A paper known as *Environs de Paris*, or sometimes called *View of the Houses and Gardens of Paris* or *The Gardens of St. Cloud*, was available in either grisaille or ocher (fig. 21). The panels shown here, in grisaille, depict the Beaujon garden, a popular Parisian park with a windmill and an early version of a rollercoaster. Other panels not shown in this illustration include the waterfalls and fountains at St. Cloud, a horse race, and another rollercoaster, at Belleville. Paris is also the subject of a well-known paper by Dufour entitled *Monuments of Paris,* reproduced here as a postcard (fig. 22). In it, people stroll on the bank of the Seine while viewing the Pantheon, Place Vendôme, and the Hôtel de Ville, which are arranged next to each other in order to suit the wallpaper's format.

Subjects that were popular in earlier wallpapers were sometimes

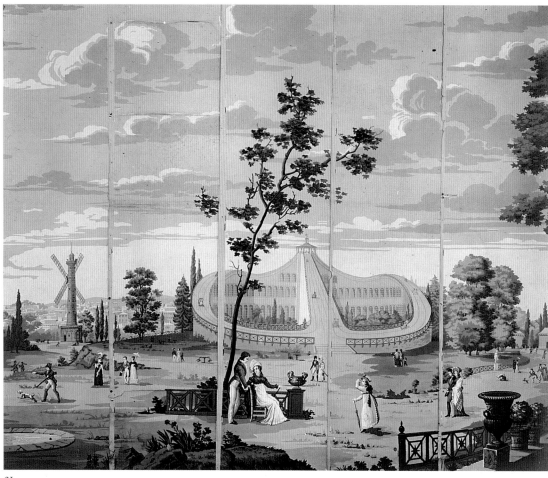

21

adapted to this new form. Aristocratic pastimes that had been common on tapestries and the earliest wallpapers made their way onto panoramic papers. Zuber's *Paysage à Chasse* (Landscape of the Hunt) features a panel of a stag hunt (fig. 23). Executed in exquisite detail, the scene is set in the Alsatian countryside, home to the Zuber factory.

In addition to sights of the Far East and Europe, points of interest in the still exotic United States appeared on a scenic wallpaper introduced in 1834—*Vues d'Amerique du Nord* (Views of North America), printed by Zuber. One section of this set shows New York Bay as seen from New Jersey (fig. 24). Fashionable people congregate in a park in the foreground

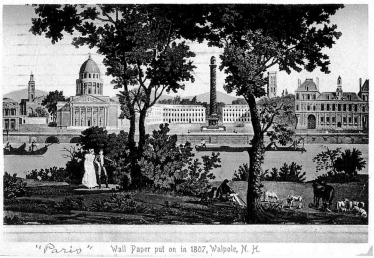

22

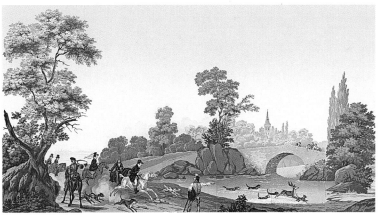

23

while Manhattan is seen in the distance. Great prominence is given—in this panel and in this set as a whole—to the Hudson River, which was an important tourist route. During the 1820s and 1830s steamboats carried tourists up the Hudson from New York City. This new tourism industry is captured in *Vues*, in which people dressed in finery are seen in the foreground of each panel. One destination on the Hudson was West Point Academy, the subject of another panel in the set (fig. 25). The Hudson River and the Catskill Mountains form the backdrop for a lively scene in which the crowd's attention is captured by soldiers on parade.

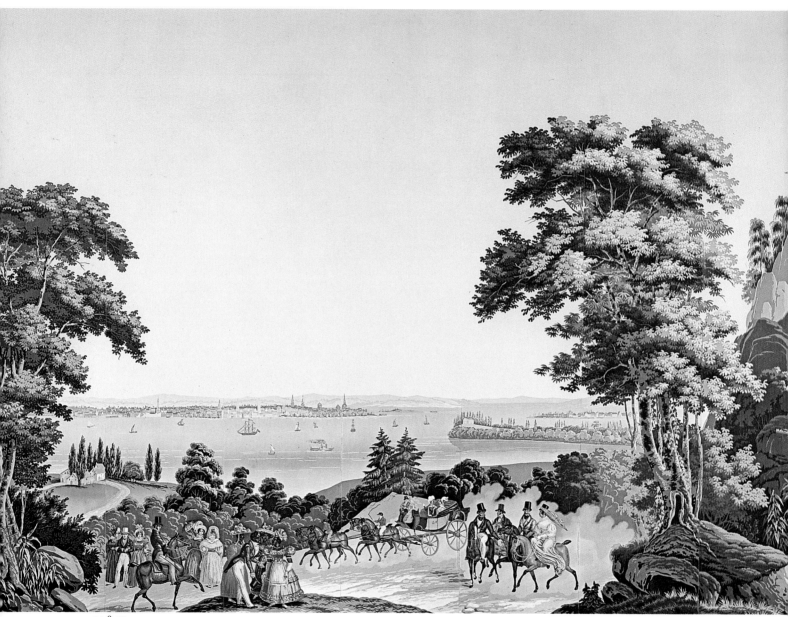

24 & 25

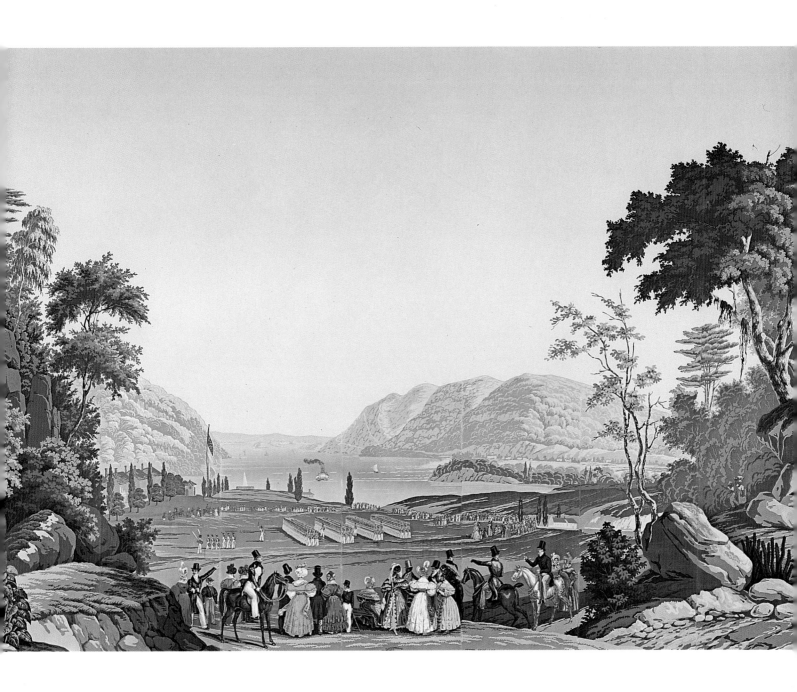

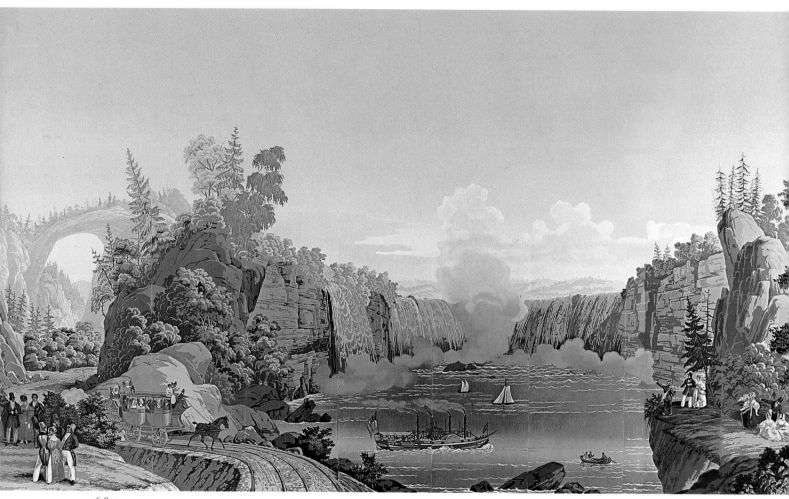

26 & 27

The ultimate destination on Hudson River tours was Niagara Falls, juxtaposed in *Vues* with the Natural Bridge—an awesome environmental wonder in Virginia (fig. 26). A steamboat full of passengers can be seen in front of the Falls, while other tourists enjoy the scenery on land. Both the Falls and the Natural Bridge were considered sublime by nineteenth-century writers and tourists. The aesthetic concept of the sublime came into use in the eighteenth century to describe an experience that was vast, terrifying, or spectacular. Sublime landscapes captured the unequaled power of nature, and they evoked intense emotion in the spectator. This

26

"The Natural Bridge of Virginia and Niagara Falls" from *Vues d'Amerique du Nord*
Rixheim, France, 1834
Printed by Zuber et Cie
Cooper-Hewitt, National Design Museum, Wallcoverings Research File

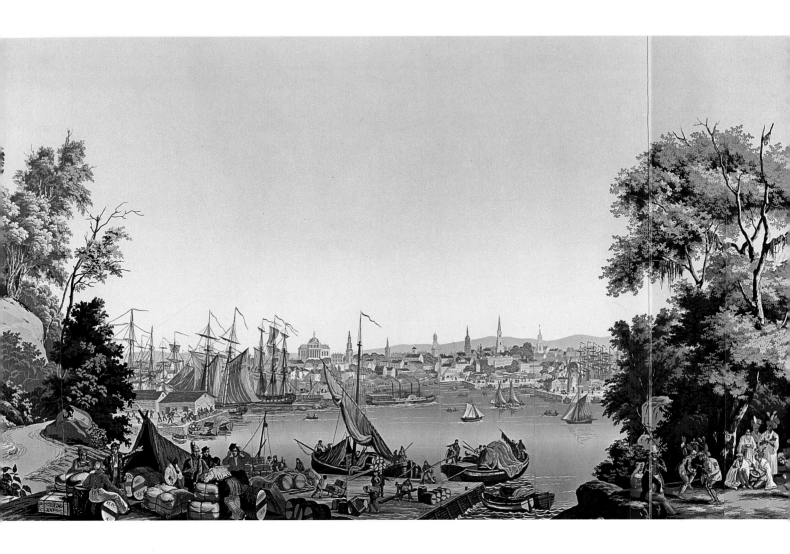

27

"Boston Harbor" from *Vues d'Amerique du Nord*
Rixheim, France, 1834
Printed by Zuber et Cie
Cooper-Hewitt, National Design Museum, Wallcoverings Research File

interest in emotional responses to nature arose out of a reaction against rationalism and the Enlightenment and by the nineteenth century had become a prevailing approach to landscape and tourism.

Another panel in the *Vues* set features Boston Harbor (fig. 27). The designer has used a published view of the city for the background of this scene, but he has filled the foreground with sailors who look distinctly European. On the right, a group of Native Americans entertain tourists with a dance.

The *Vues* set, based on Jacques-Gérard Milbert's 1828 book, *Picturesque*

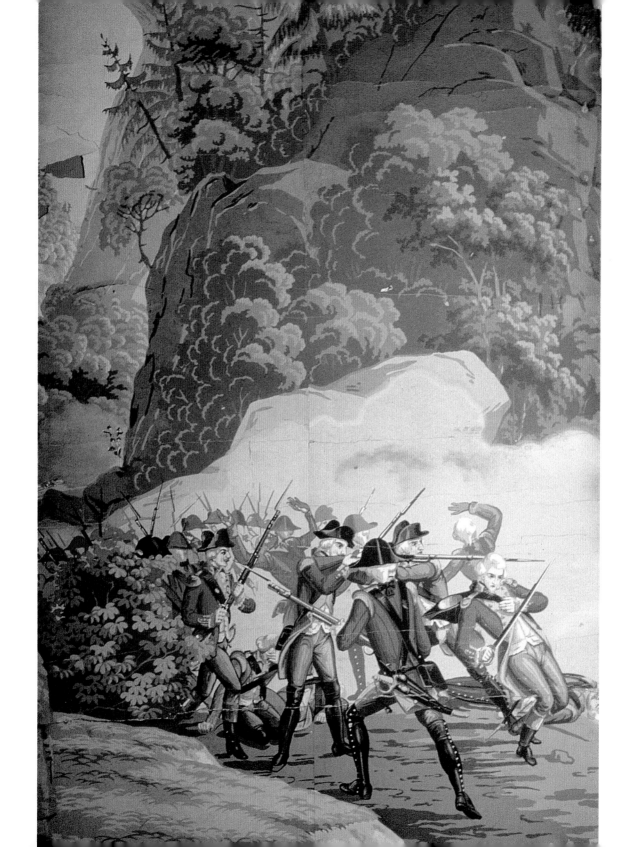

28

Detail of *Views of the American War of Independence*
Rixheim, France, 1852
Designed by Jean-Julien Deltil
Printed by Zuber et Cie
177.5 × 90.5 cm
Gift of A. L. Diament and
Company, 1954–147–4
Photo by Gregory Herringshaw

29

Photograph of the Hall in the
Moffat-Ladd house in Portsmouth,
New Hampshire
Shows Dufour's *Views of Italy*
(originally printed 1820–25) *in situ*
Cooper-Hewitt, National Design
Museum, Wallcoverings Research
File

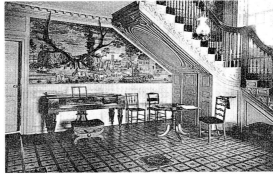

29

Itinerary of the Hudson River and the Peripheral Parts of North America, was designed by Jean-Julien Deltil. Milbert had traveled to the U.S. to serve as an engineer during the building of the Erie Canal and became fascinated with the topography of the eastern seaboard, but it is likely that Deltil never set foot in the United States. *Vues* is still printed by the Zuber company. It received wide notice when Jacqueline Kennedy had it installed in the White House in the early 1960s—a choice that underscores the nationalistic values inherent in these papers at their inception and today.

Manufacturers could sometimes update or change the subject matter in a scenic paper. If the clothing was no longer fashionable, a few woodblocks could be cut in order to bring things up to date. In 1852 the Zuber company used the background of *Vues d'Amerique du Nord* to make a new scenic, which was called *L'Indépendance Américaine* (American Independence). The original carriage in the panel with the Natural Bridge (see fig. 26) was replaced with soldiers engaged in battle (fig. 28). Such changes allowed manufacturers to offer a broader variety of subjects while reducing the large initial investment needed to design a paper and carve the necessary blocks.

Panoramics in Use

Photographs of panoramic papers as they were hung in American homes reveal that they were not always used as envisioned by the manufacturers. Once installed in the context of a home, these papers were the backdrop for all manner of furnishings. In an early twentieth-century photo of the main hall of the Moffat-Ladd House in Portsmouth, New Hampshire (built in 1763), a panel of Dufour's *Views of Italy* is visible on the wall with a set of antlers obscuring part of the paper (fig. 29). Scenic papers were

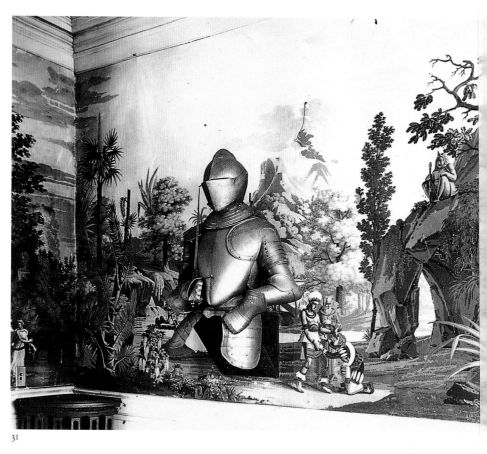

30

31

often hung in hallways, where large furniture did not usually get in the way and the papers could immediately impress visitors. *Views of Italy* was originally offered around 1820–25 and was printed in grisaille, olive green, maroon, yellow ocher, and sepia. Italian scenes were one of the most popular subjects offered between 1810 and 1840, with six Italian-themed scenics by different makers recorded. Dufour's *Views of Italy* depicts the bay of Naples with Mt. Vesuvius erupting, antique ruins, port scenes, picturesque countryside, and a waterfall.

Two photos of The Lindens, now a historic house in Washington, D.C., and formerly in Danvers, Massachussetts, show more scenic papers. *Les Incas* (The Incas), printed by Dufour around 1818 (fig. 30) and depicting scenes from Francisco Pizarro's sixteenth-century conquest of Peru, hangs in the entry hall with a partial suit of armor (fig. 31). Although to

30

Les Incas
Macon, France, 1818
Printed by Dufour
Plate XXV from *Tableaux-Teintures de Dufour & Leroy*, Cooper-Hewitt, National Design Museum branch, Smithsonian Institution Libraries

31

Photograph of the Hall in The Lindens, Washington, D.C.
Shows *Les Incas in situ*
Cooper-Hewitt, National Design Museum, Wallcoverings Research File

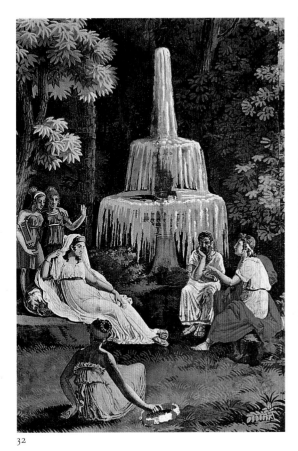

32

33

the contemporary eye mounting large objects on luxury wallpaper might
look incongruous, the practice has a long precedent. Mirrors and portraits
were sometimes hung on the tapestries that predated wallpaper.

Another wall of The Lindens featured Dufour's *Les Paysages de
Telemaque dans l'île de Calypso* (Landscape of Telemachus on the Island
of Calypso) (fig. 32). *Les Paysages de Telemaque* relates the mythological
story of Telemachus, son of Odysseus. After the Trojan War,
Telemachus set out to search for his father. His travels eventually ship-
wrecked him on the island of the nymph Calypso, who fell in love with
him. In the scene shown here, Calypso conspires to keep Telemachus
on the island by encouraging him to tell her of his previous adventures
(fig. 32). Such a story had dual appeal as a wallpaper subject, since both
mythological stories and exotic locales were so popular.

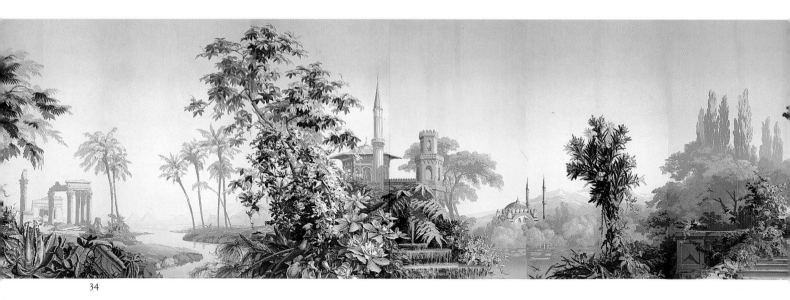

34

At The Lindens, *Les Paysages* may have been hung in the same hall as *Incas*. Combining papers was not entirely uncommon in the United States. When the wallpaper supplier did not have an entire set in stock, a panel was damaged in storage or transit, or the room to be papered was so large that one set would not cover the walls, panels from more than one set were combined. This practice made it difficult in the past to identify the full scope of scenic paper sets.

El Dorado

One of the most grandiose panoramic papers was Zuber's *El Dorado*. First manufactured in 1849, this paper presents four major continents—Europe, Asia, Africa, and America—in a suite that would have filled a room (fig. 34). Each continent is represented by its native vegetation and architecture as they were interpreted by Zuber's designers. A flower-covered terrace overlooking a lake represents Europe; minarets, a pagoda, and architectural ruins from near the Bosporus Strait symbolize Asia; the Nile River, Egyptian ruins, and desert plants recall Africa; and lush flora, distant mountains, and a small city near Vera Cruz, Mexico, reflect the Americas. Unlike previous panoramics, which often contained peopled narratives, *El Dorado* features the landscape in its edenic glory as the complete subject. One can only imagine the effect this paper must have had on the viewer, who found him- or herself at the center of the world.

34

El Dorado
France, 1849
Designed by Eugène Ehrmann, Georges Zipélius, and Joseph Fuchs
Printed by Zuber et Cie
Copyright © Zuber et Cie
Block printed
24 panels: 199 × 54 cm each
Gift of Dr. and Mrs. William Collis, 1975–77–1
Photo by Ken Pelka

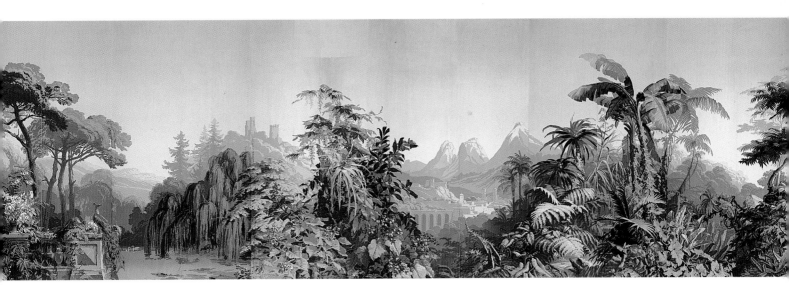

This amazing illusion, which is still manufactured by Zuber today, was designed by Eugène Ehrmann, Georges Zipélius, and Joseph Fuchs. Ehrmann and Zipélius were two illustrators who specialized in botanical renderings. The paper took approximately two years to complete, from inception through production.

The title *El Dorado* (The Golden One) is derived from the Spanish legend of a city of great wealth in which everything, from buildings to clothing, is made of gold. Sixteenth-century explorers believed this kingdom existed in present-day Colombia and used the search for El Dorado to justify their exploration and domination of what is now South and Central America, Mexico, and even the southwestern United States. Throughout the nineteenth century, treasure seekers continued to search for the gold of El Dorado, but by the time this paper was manufactured the name had come to mean a place of great wealth, opportunity, or abundance—a mythical place that almost anyone would welcome into his or her home.

Landscape Figures

The expense of panoramic papers limited their market and created a demand among the middle class for more modestly produced wallpapers. The landscape imagery celebrated by Zuber, Dufour, and others was often adapted by manufacturers in France and other countries for less expensive designs, called landscape figures. These papers depicted small

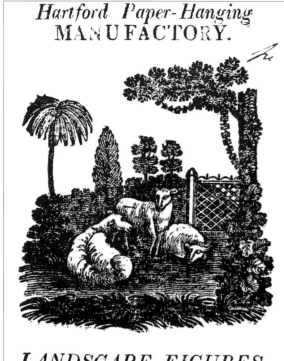

35

Advertisement for a landscape
figure from the newspaper
American Mercury
Hartford, Connecticut, October 16,
1816
Courtesy Connecticut Historical
Society, Hartford

36

Detail of landscape figure
Reproduction (1920–34) of a block-
printed paper from c. 1825
Buffalo, New York
Printed by the Birge Company
Machine printed
41 × 36 cm
Gift of D.M.C. Hopping,
1973-70-26

vignettes of exotic people and scenery, classical scenes, and pastoral
themes including cows and sheep. The small scenes were alternated with
another motif, either another vignette or a decorative element.

An 1816 advertisement for "landscape figures" produced by the
Connecticut firm Woodbridge and Putnam attests to the popularity of this
genre (fig. 35). The scene of three sheep in a gardenlike landscape is copied
directly from another wallpaper, which most likely was French (fig. 36). The
pastoral theme of both images suggests the widespread influence of Jean-
Jacques Rousseau, the eighteenth-century French philosopher credited
with the glorification of a simple way of life. Rousseau believed that
human beings were essentially good in their "natural" state but became
corrupted by politics and business. Many landscape figure papers capture
his ideal as it was popularly interpreted. They are full of children playing,
men fishing, and women tending flower gardens.

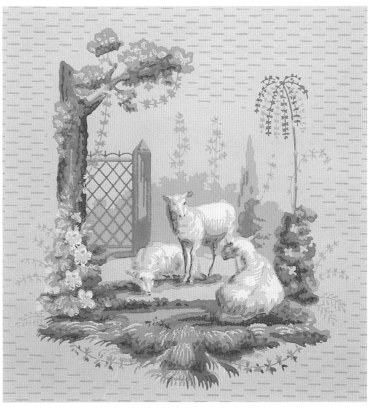

36

Rousseau's philosophy shaped nineteenth-century Romanticism. In a reaction against the rationalism of the Enlightenment, the violent aftermath of the French Revolution, and the destabilization of society caused by the industrial revolution, Romanticism embraced an emotional response to the world and celebrated nature in its rawest and richest states. A French paper from the early nineteenth century, shown on parlor walls of the Lindall House in Salem, Massachusetts, emphasizes the bounty of nature (fig. 37). It depicts four scenes: birds feeding their young; a man on horseback hunting a stag; melons, fruits, and flowers; and a lone deer surveying the landscape (fig. 38).

While the Romantic movement thrived in the arts, new technologies fascinated another segment of the public. In a landscape figure from around 1820, the main image is a water-pumping station (fig. 39). Simultaneous with this paper's manufacture, the Fairmount Waterworks

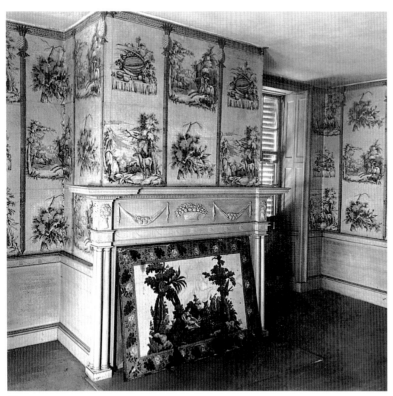

37

were constructed in Philadelphia. The Fairmount structure was seen as a political symbol. As art historian Amy Ellis has noted about Fairmount, "Considered an engineering feat, the waterworks were set on five acres that were landscaped according to the picturesque theory. They opened in 1815 as an early example of the public garden, which was to be the democratic answer to the great estate gardens of England and Europe. The combined celebration of both landscape and technology implicit in Fairmount park, as the site came to be called, typified America's changing attitudes toward the landscape. Technology could now be used to harness the vast natural resources of the United States in order to create a democratic society of order and prosperity" (Ellis in Johns, ed., *New Worlds from Old*, p. 138).

New modes of transportation, which facilitated touring as a leisure-time activity, also held a fascination for nineteenth-century audiences. An American wallpaper depicts the Erie Canal, which was built between 1817 and 1826 (fig. 40). It opened trade and travel from Buffalo, New York, and

37

Landscape figure
Photograph of parlor in Lindall
House, Salem, Massachusetts,
c. 1900
Courtesy Peabody Essex Museum,
Salem, Massachusetts

38

Hunting scene and vignette with birds
United States, 1835–45
20th-century reproduction
Block printed
121 × 57 cm
Gift of Miss Grace Lincoln Temple,
1938–62–45–a

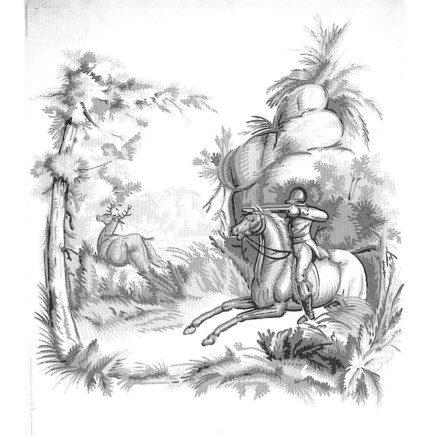

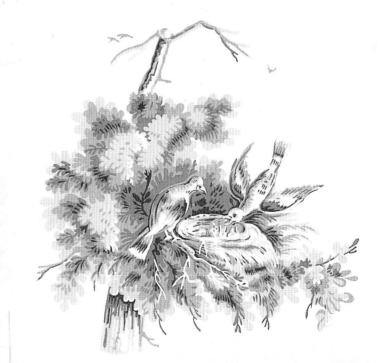

38

39

39

Waterworks with Flower
Probably United States, c. 1820
Block printed on joined sheets
59.5 × 51.0 cm
Gift of the Museum at The Fashion
Institute of Technology,
1998–75–164

40

Bandbox with the Grand Canal
(Erie Canal)
United States, c. 1834
Block printed
37.5 9 (h) × 28.0 (w) × 26.0 (d) cm
Gift of Mrs. James O. Green,
1913–12–9–a,b

the upper Midwest to Albany and New York City and the world beyond. When it opened, the Canal was the longest in the world and was admired as a great American achievement. The Canal became part of the first tourist route in the United States, from New York City to Niagara Falls. The paper is shown here on a bandbox, a type of carrying case typically covered with wallpaper and used for travel or as an early form of shopping bag.

An essential innovation in expanding reliable transportation was the steam engine, patented by James Watt in 1769. It revolutionized boat and rail travel. By the 1830s, the American continent was being crisscrossed with railroad tracks. A paper from the period, possibly produced in the United States, captures a train with a steam engine in one vignette, and a port filled with sailing ships in another—a decorative reference to new and old transportation systems (fig. 41).

40

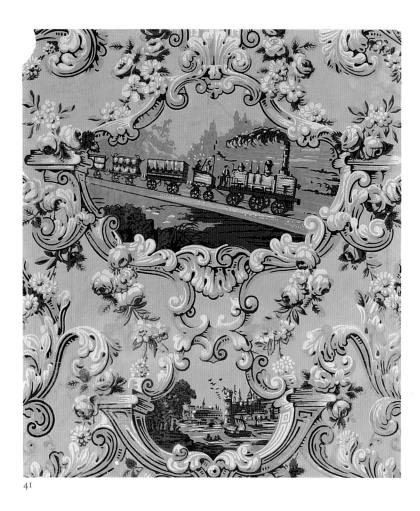

41

41

Scenes of train travel and a port
framed by cartouches
Possibly United States, 1835–50
Block printed
49.5 × 48.5 cm
Gift of Wiscasset Public Library,
1985–36–1b

42

Wallpaper depicting scenes of a
town and an Alpine village
France, c. 1850
Block printed
61.0 × 49.5 cm
Gift of Thomas Strahan Co.,
1976–46–30

Scenery Figures

By the 1840s the phrase "scenic touring" had become part of the English
language. Wallpapers featuring travel and landscape vignettes came to be
called "scenery figures." (Sometimes they were also called "medallion"
papers because of the heavy frames surrounding the scenes.) One such
paper from around 1850 shows unidentified European scenes that con-
trast rural and urban settings (fig. 42). Fishermen in the foreground of the
port scene, an arched bridge, and the shepherd tending his flock before a
sleepy village were all well-worn conventions by this time. The mountain
shown in the background (perhaps the Swiss Alps, an important tourist
destination) was a romantic emblem representing the grandeur of nature.

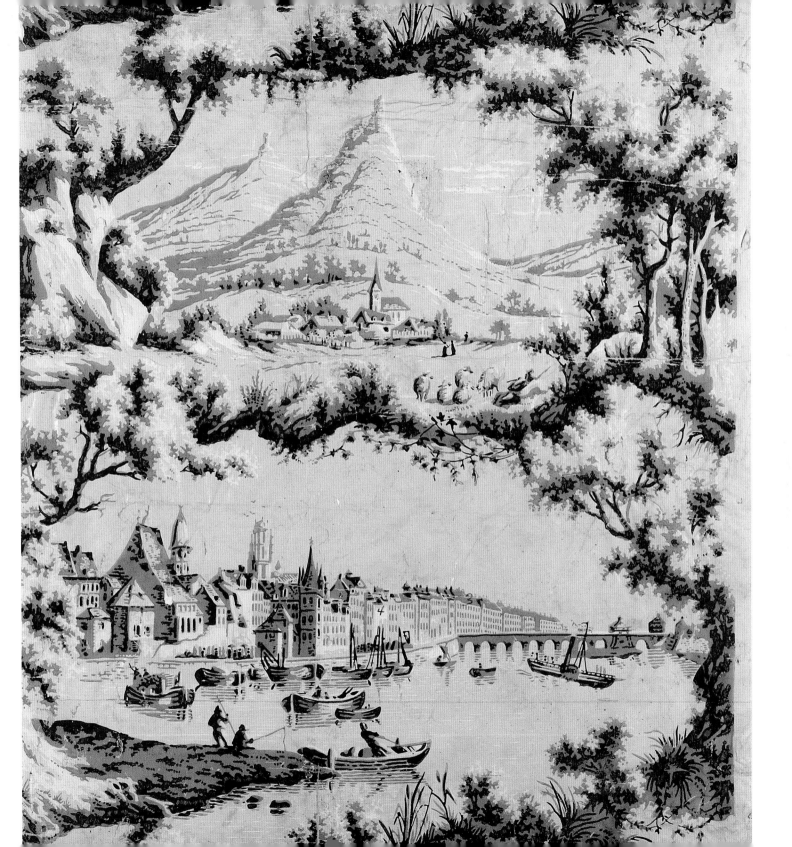

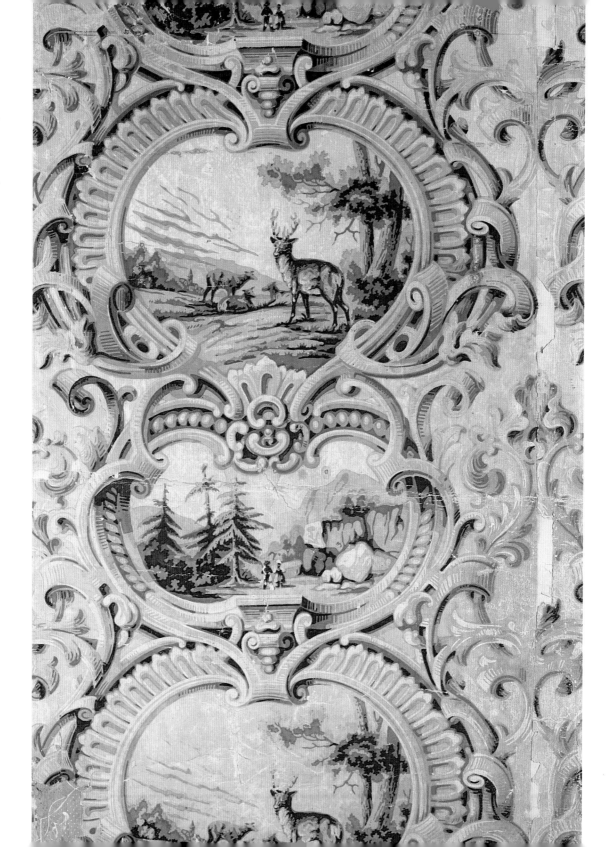

43

Mountain views with stag and
figures
Probably United States, 1845–60
Block printed
83.0 × 61.5 cm
Gift of Jones and Erwin, Inc.,
1970–26–24

A block-printed scenery figure from around 1845 to 1860 appears to depict the Catskill Mountains in New York amid heavy rococo revival framework (fig. 43). The Catskills had been a tourist attraction since the 1820s when a grand hotel, the Catskill Mountain House, was erected to take advantage of the dramatic views, rushing waterfalls, and other natural effects in the region. The two alternating scenes in the wallpaper are of a couple walking on a forested path and a deer emerging from the forest in a clearing. Their juxtaposition—with people and animals sharing the same forest—suggests the intersection of culture and nature brought about by the rise in landscape tourism.

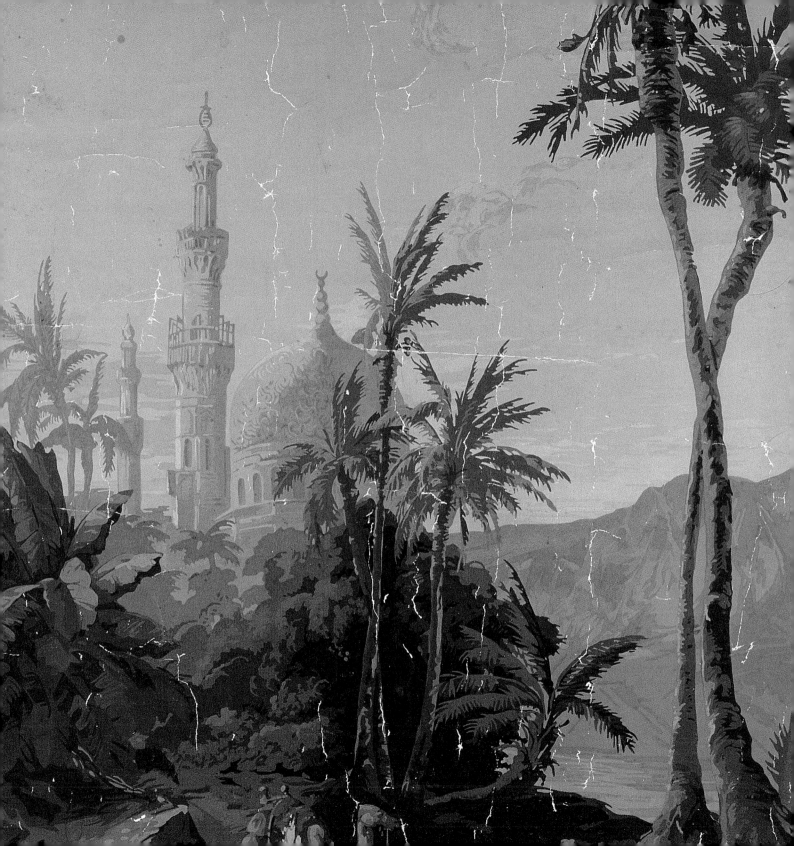

New Horizons, 1850–1900

Paperhangings form a manufacture of considerable importance carried on in most of the principal cities of Europe, employing many artists and designers and thousands of operatives, consuming also vast quantities of paper, colours, wool and metal. They are important also because they may be made the means of extensively diffusing the taste for art; and from the low price of the cheaper kinds, enabling the humblest mechanic to give his home an air of elegance and comfort.
　　—Official Catalog of the Great Exhibition, 1851

The Great Exhibition, also known as the Crystal Palace exhibition, opened in 1851 in London. This landmark international fair was the first of what became the world's fairs, at which all nations are invited to display the best of their arts and manufactures. At the Crystal Palace, approximately fifty wallpaper manufacturers exhibited their products with especially elaborate entries from the French and English companies. The wallpaper companies in England and France were the source for almost all the Western world's wallpaper at mid-century. Each country was printing approximately two million rolls of wallpaper per year, each attracting distinct markets, with the French continuing to make the most luxurious papers and the English focusing on technological improvements and mastering mass-production.

French Wallpaper Styles

French manufacturers strove to have their papers perceived as a form of industrial art, instead of mere industrial production. French papers were described as "painterly" because of the careful attention paid to the shading and coloring of the subject matter. Artists were also commissioned to design new papers. By mid-century, Romantic and mythological views

Opposite

Detail of figure 49

were replaced in French production with more architectural, more ornate *décors*. Known as "pilaster and panel" papers in England and as "fresco" papers in the U.S., *décors* resembled huge paintings framed in elaborate friezes, pilasters, and dadoes. They added architectural interest to the room in which they were hung and presented an illusion that the room contained a work of art.

Landscapes were often the subject of *décors*, as seen in *Décor Elysée*, produced by the Parisian firm Delicourt et Cie (fig. 44). This paper depicts an idealized garden filled with sculptures and flower-covered pilasters, balustrades, and cornices. In this reproduction, from a lithographic album of such papers available from the firm at the time, a choice of friezes is shown, suggesting the mix-and-match nature of *décor* papers. *Décors* came in sets of pilasters, dadoes, and friezes that could be assembled in various ways to fit different rooms. They were produced in many of the popular ornamental styles of the day, including Renaissance, Elizabethan, or Rococo revival.

The Delicourt firm was founded in 1838 by Etienne Delicourt, who began his career at the Dufour company. By 1852, when the Second Empire began in France, Delicourt had become one of the country's most important wallpaper manufacturers. His papers often won awards, and at the 1851 Crystal Palace exhibition, his firm took the highest honors for *La Grande Chasse*, a large-scale landscape paper designed by Antoine Dury.

One of Delicourt's top competitors was Desfossé & Karth, founded in 1851 by Jules Desfossé. (Hippolyte Karth became a partner in 1863.) Desfossé produced both scenic papers and *décors*. The quality of the firm's work can be seen in the frieze from a paper entitled *Décor Pastoral* (figs. 45 a,b). This scene of cows grazing reflects the newly popular painting style of the period—the realism of the Barbizon school. Named after a village near Fontainebleau, the Barbizon group of painters included Jean-François Millet (1814–1875), and Jean-Baptiste Corot (1796–1875), as well as other artists retreating from an increasingly industrialized society. Heavily influenced by seventeenth-century Dutch landscape painters, Millet and Corot painted the countryside and its inhabitants naturalistically and paved the way for the Impressionists a few years later. *Décor Pastoral* seems to illustrate Millet's observation that farm animals were suitable subjects for painting because they were in perfect harmony with nature. This frieze, as well as the painting style that inspired it, stands in marked constrast to the idealized version of nature found in the traditional landscape paintings of Claude Lorrain and Nicolas Poussin

44

Décor Elysée
France, 1838–59
Reproduced as a plate in *Collection d'Esquisses, Delicourt et Cie*
Cooper-Hewitt, National Design Museum branch, Smithsonian Institution Libraries

45a

45a

Décor Pastoral, frieze
France, 1863–65
Jules Desfossé
Block printed
57.5 × 165.5 cm
Purchase, Friends of the Museum, 1955–12–3a

44

45b

Décor Pastoral, frieze with capital
France, 1863–65
Jules Desfossé
Block printed
57.5 × 67.0 cm
Purchase, Friends of the Museum,
1955–12–4

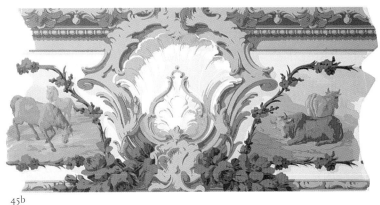

45b

46

46

Décor Pastoral, detail of hanging
medallion
France, 1863–65
Jules Desfossé
Block printed
140 × 70 cm
Purchase, Friends of the Museum,
1955–12–2

47

L'Orage
France, 1863
Designed by Eugène Ehrmann,
after a painting by Robert Eberle
Zuber et Cie
Block printed
231.8 × 193.7 cm
Gift of Harvey Smith,
1968–130–13–b

(1594–1665). Throughout the second half of the nineteenth century, this rivalry between idealism and naturalism in art continued, as the French Academy and the Ecole des Beaux-Arts resisted the increasing naturalism and spontaneity of the Barbizon painters and, later, the Impressionists.

At the same time that the Barbizon painters were breaking new ground, Empress Eugénie, wife of Napoleon III, who ruled France from 1852 to 1870, revived the pastoral motifs that had been favored by Marie Antoinette (1755–1793). In 1783 Marie Antoinette had a small farm built north of Paris where she kept sheep and cows. This superficial view of farm life is reflected in the hanging medallions of the *Décor Pastoral* (fig. 46).

In some cases, the relationship between landscape painting and wallpaper design was immediate. The Zuber firm introduced *L'Orage*, also known as *Les Vaches*, based on a painting by Robert Eberle (1815–1862) (fig. 47). The paintings of Eberle, who had studied Dutch painting and

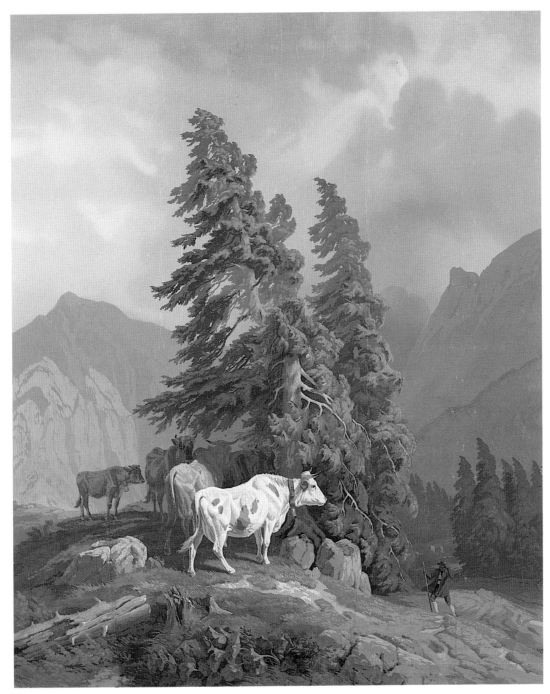

47

had been influenced by the powerful landscapes of Jacob van Ruisdael (c. 1628–1682), often featured rural scenes, especially in the Swiss Alps. They were frequently made into popular engravings, which may be how the Zuber company came to reproduce them. (Two other Eberle paintings, *Le Berger* and *Les Chèvres des Alps*, were also transformed into large-scale wallpapers by Zuber.) These quasi-paintings would have been hung singly on the wall and framed with wallpaper borders, dadoes, and friezes.

During the nineteenth century, Switzerland was essentially an agrarian economy; its mountainous terrain was used for pasture and farming. Eberle beautifully captured the pastoral side of Switzerland, as well as the awe that the country's mountains and glaciers inspired. In the 1840s, Switzerland began to attract tourists as its first railway lines threaded their way across the Alpine mountains. By the 1850s, its role as tourist destination was well established. In another Desfossé & Karth *décor*, the bases and capitals of twelve-foot pilasters showcased popular Swiss scenery (figs. 48 a,b). The pilasters are rendered in a trompe-l'oeil fashion and appear to stand out from the wall. The Swiss mountains and glaciers are shown in windowlike views, turning the whole ensemble into a double illusion. The title of this paper, *Régence*, refers to a delicate decorative style prominent in France in the early eighteenth century.

A similar "window" motif is used in *Le Soir* (fig. 49). Installed in a home, it would have afforded views through illusory carved and gilded frames to the Middle East, with palm trees, minarets, and mounted camels. The other "windows" in this *décor*, framed in the same manner, showed the exotic desert landscape at different times of the day.

Western interest in the Middle East was intense in the middle of the nineteenth century. The British explorer Sir Richard Burton (1821–1890) spent most of his career exploring the region and publishing his experiences. At the same time, chromolithography—a form of lithography in which separate printing plates were used for each color—was perfected and offered an alternative to hand-colored illustrations in books. As a result, full-color travel books were mass-produced in portable editions, and the Middle East was a particularly popular subject. One of the most significant travel books published on the region at the time was *Sketches in the Holy Land, Syria, Idumea, Arabia, and Nubia*, produced between 1842 and 1845 by David Roberts.

Chromolithography was employed in the production of wallpaper as well as books. It was used to print a small view of a Swiss chalet framed in gold and referred to as "stamped gilt" paper (fig. 50). First the lithograph was

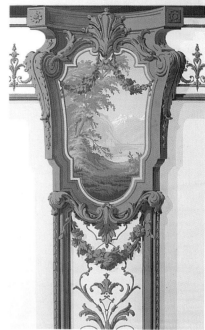

48a

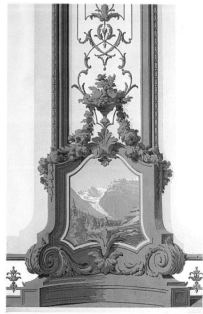

48b

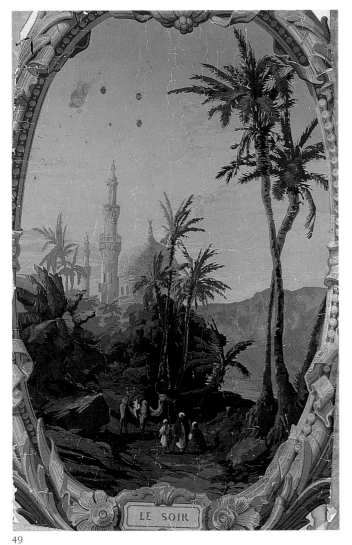

49

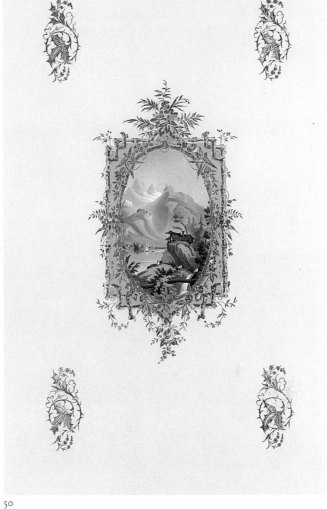

50

48

Régence, pilaster capital and base
France, 1851–65
Desfossé & Karth
Block printed
290 × 57 cm
Gift of A. Germain, 1955–3–1

49

Le Soir
France, c. 1855
Block printed
90.5 × 54.0 cm
Gift of Mrs. Germaine Little,
1968–113–4

50

Alpine scene with chalet
France, 1835–50
Block printed, color lithograph, gilt
stamped
75 × 50 cm
Gift of Eleanor and Sarah Hewitt,
1931–45–70

printed, probably by a specialist firm hired by the wallpaper company. Then the blue surround and pattern were block-printed, and the metal leaf was applied. Finally, the frame and the small repeating elements were stamped with finely cut metal dies under high pressure. The stamped gilt process was used to create fancy gift books at mid-century, and both stamped gilt papers and books could be found in parlors during the 1850s and 1860s.

Gilt began to appear more frequently on wallpapers as a flourish. In a softly colored French paper from about 1865, gold is used on the medallion (fig. 51). Enclosed in this sparkling eighteenth-century-style frame is a humble thistle, a plant usually associated with Scottish ornament, in its natural habitat. In this context, the thistle represents one of the indigenous European plants that were of great interest during the nineteenth century. The geographer Alexander von Humboldt attracted a large international audience with books about the physical history of the earth at roughly the same time that Charles Darwin published *The Origin of Species,* in 1859. For amateur naturalists, illustrated field guides were published to support the burgeoning pastimes of collecting plants or minerals or identifying bird species. *Wild Flowers* was published by Anne Pratt in 1851, and *Common Wayside Flowers* appeared in 1870. A book illustration may have inspired the thistle in this wallpaper, continuing the tradition of papers based on previously published images.

The Impact of Machine Printing

Machine printing was introduced into the wallpaper industry in 1839, when Potters & Ross, a British textile printer, patented the first machine. In machine printing, the design for a paper was applied to a wooden roller (fig. 52). Brass strips outlining the design were pounded into a wooden roller and filled in with felt, which then held the color. Similar to block-printing, each color required a separate roller, but instead of printing one color at a time and allowing it to dry before applying the next color, machine printing saved time and labor by applying all of the colors in rapid sequence as the paper passed under different rollers. In fact, colors had to be thinned and adapted chemically to dry faster in order to avoid blurring the printed image. Synthetic pigments such as chrome yellow and ultramarine blue were used on the now widely affordable wallpaper. Rolls of continuous paper made from wood pulp instead of cotton- or linen-rag fiber further reduced the cost of wallpaper.

Machine printing also changed the scale of the design. The circumfer-

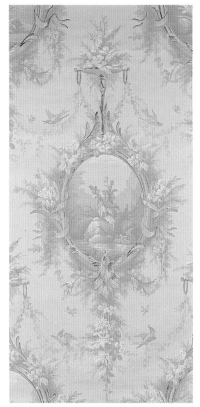

51

51

Repeating motif of thistle in
roundel
France, c. 1860
Block printed
123 × 70 cm
Museum Purchase from the
Smithsonian Institution,
1994–101–10

52

Surface-printing roller
United States, mid-19th century
F. E. James Company
Wood and metal
55.5 × 13.0 (diameter) cm
Gift of Miss Myrta Mason,
1943–54–1

53

The Horse Fair, after Rosa
Bonheur's painting *The Horse Fair*
England, 1855–75
Machine printed
77.5 × 56.0 cm
Gift of Eleanor and Sarah Hewitt,
1928–2–73

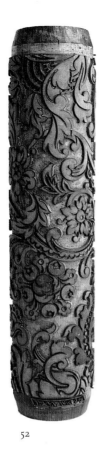

52

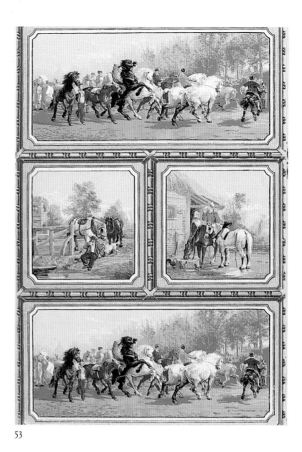

53

ence of the new rollers was relatively small, so the size of each repeat was
reduced, resulting in smaller scale designs and more compact views of
nature. While French manufacturers continued to specialize in hand-
printed papers, English and American manufacturers took advantage of
the newest technology. Large, nonrepeating papers, such as Zuber's
L'Orage (see fig. 47), were far too extravagant and possibly even too large
for the average household. An affordable alternative was an English wall-
paper machine-printed with the image of another well-known painting,
The Horse Fair, by Rosa Bonheur (1822–1899). From 1853 Bonheur's paint-
ing had been widely reproduced as an engraving (fig. 53). As with many
machine-printed papers intended for a mass market, the manufacturer of
this paper is unknown. It was not until the late nineteenth century that
manufacturers of machine-printed papers began to print their names on
the selvage (or uncut) edge. Based on other sources, however, it is likely

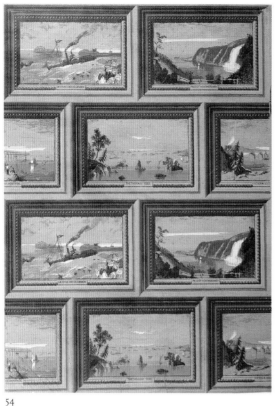

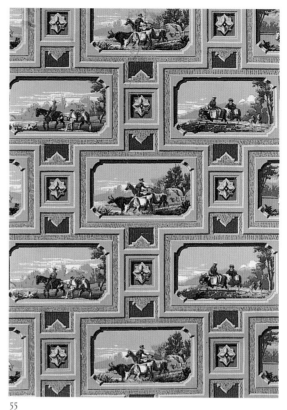

54

55

that the firm responsible for *The Horse Fair* was Heywood, Higginbotham and Smith, who had received a gold medal at the 1851 Crystal Palace exhibition for the quality of their machine-printed papers. By the 1880s Heywood, Higginbotham and Smith exported wallpaper to all parts of the globe.

Another paper attributed to Heywood, Higginbotham and Smith re-creates Canadian landscape scenes in framed vignettes (fig. 54). The thin colors have been printed to create the impression of a watercolor painting. The original light tan color of the paper was used as part of the design, saving the use of one roller. The tourist views depicted in this paper from about 1870 include the scenic Thousand Islands, Montmorency Falls, La Chine Rapids (with its thrilling boat ride over the rapids), and the man-made wonder of the Victoria Bridge. This railway bridge, constructed of wrought iron between 1854 and 1859, was a major engineering feat and became a tourist destination.

54

Framed Canadian scenes (La Chine
Rapids, Montmorency Falls, The
Thousand Islands, Victoria Bridge)
England, c. 1870
Machine printed
75.5 × 56.0 cm
Purchased in memory of George
Arnold Hearn, 1943–25–1
Photo: Ken Pelka

55

Framed scenes with figures on
horseback
United States or England, c. 1870
Machine printed
62 × 57 cm
Gift of Eleanor Mitchell, 1947–52–1

In the second half of the nineteenth century, wallpaper manufacturers made use of another source for landscape and other imagery: the booming magazine industry in Europe and America. In America, for example, about 700 magazines were published in 1865, but twenty years later that number had jumped to about 3,300 due to developments in printing press technology and a more widely educated and literate public. *Ladies' Home Companion, Scientific American, Scribners,* and *Harpers and Leslie's,* to name just a few popular titles, were filled with travel articles, literature, fashion, scientific breakthroughs, and current events. Moreover, they were well illustrated. Electrotyping, a process that creates a facsimile of type or an engraving, revolutionized the printing of pictures.

Contemporary scenes and popular literature made their impression on wallpaper producers—and buyers—during this period. A machine-printed wallpaper from around 1870 depicts a quintessentially American version of the pastoral myth—the cowboy on the frontier (fig. 55). Although the source for this image, which heroizes the self-reliant and rugged cowboy, is unknown, it is very likely to have been a magazine. Cowboys herding cattle have replaced shepherds relaxing in the hills, and the frame for each vignette has been made suitably rustic.

Current events became common on machine-printed papers. Subjects included scenes from the Crimean War (1853–56), the 1851 Crystal Palace exhibition, the Paris Exhibition of 1855, and the Prince of Wales's visit to India. Outdoor scenes from the novel *Robinson Crusoe* were illustrated on a paper from the 1870s designed especially for children's rooms. Wallpapers were also put to other uses. A bandbox is covered with a wallpaper that depicts Gallipoli, a Turkish naval base (fig. 56). Papers such as these reflect the tastes of wallpaper's new middle-class market, which grew when machine printing made papers more affordable.

Eastern Influence and Stylization
Late nineteenth-century consumers interested in the aesthetic vanguard looked to designers Owen Jones, William Morris, and Christopher Dresser as the creators of new approaches to decorating a wall. Jones (1809–1874) preached the beauties of geometric ornament and flat pattern and produced wallpapers with beautiful, rhythmic patterns instead of recognizable scenes. Morris (1834–1896) inspired a return to the pre-industrial past. His well-known wallpapers, still in production today, depict stylized plant forms that cleverly conceal their repeat. They were printed by hand with wooden blocks by the London firm of Jeffrey and

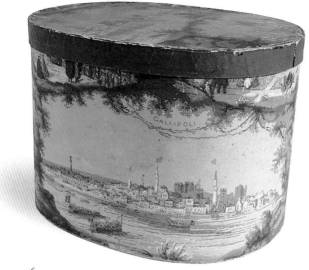

56

56

Bandbox, covered with wallpaper
showing scenes of Gallipoli and
Istanbul
United States, 1860–70
Block printed
30 (h) × 26.5 (w) × 22.5 (d) cm
Gift of Eleanor and Sarah Hewitt,
1913–17–13–a,b

57

Japonaiserie-style paper with
landscape vignettes
United States, c. 1885
Machine printed
186 × 49 cm
Acc. no. n-w-226

Company. Dresser (1834–1904) was interested in designing for the
machine, which he believed would bring better design to all people. He
also advocated using ornament from other cultures, as did Jones, but
where Jones was most interested in the Middle East, Dresser was taken
with Japan.

Japan had been off-limits to Western traders for centuries, until 1854,
when the United States arranged a trading agreement with the emperor.
Europeans first saw Japanese objects—ceramics, prints, bronzes, and tex-
tiles covered with ornament based on stylized natural forms—at the 1862
International Exhibition in London. They were immediately attracted to
Japanese patterns and motifs, the cropping of objects as part of a work's
composition, and the flat, awkward rendering of perspective. Artists such
as Claude Monet, Edouard Manet, and James Whistler began to incorpo-
rate these elements into their paintings.

Wallpaper design was much affected by these new inspirations and the
public fascination with them. By the 1880s, pattern books filled with
Japanese ornament proliferated, and all kinds of objects were covered
with bamboo, fans, cherry blossoms, cranes, and oriental-style vases.
Many beautiful papers were produced in a Japanese mode. A strange and
interesting expression of this mania for things Japanese are the "Anglo-
Japanesque" wallpapers, such as the example shown here (fig. 57).

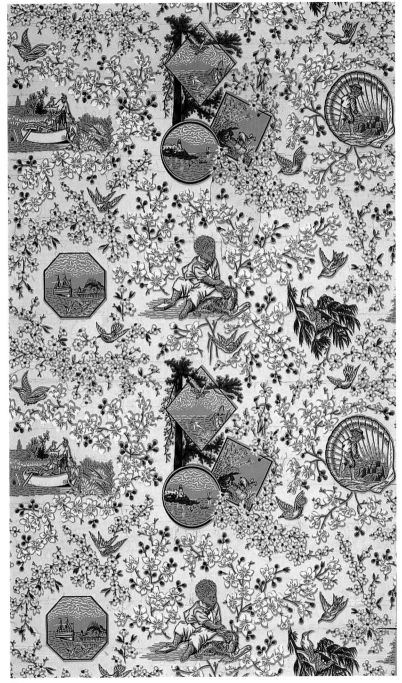

57

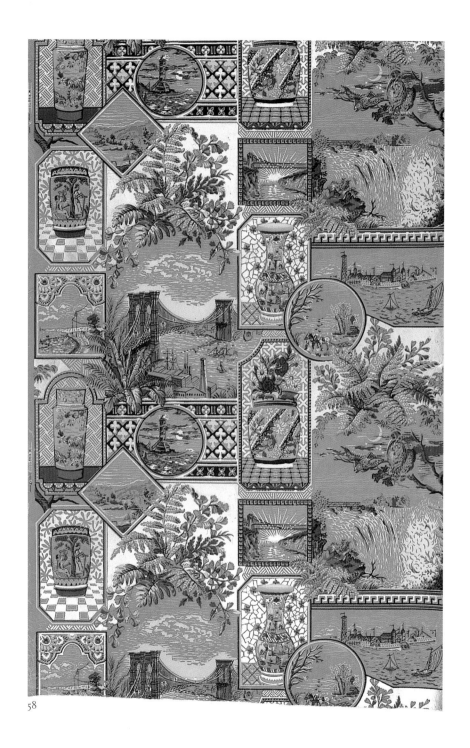

58

58

Japonaiserie-style paper, with views
of the Brooklyn Bridge and Niagara
Falls
United States, 1883–85
Machine printed
74.5 × 47.0 cm
Gift of Grace Lincoln Temple,
1938–62–18

Produced in the U.S. around 1885, this paper uses one of the characteristic palettes of the period—an olive ground with yellow and maroon highlights. The design, which resembles postcards tacked on a blossom-strewn wall, is composed of asymmetrical landscape elements placed in loose groups surrounded by cherry and possibly apple blossoms. Instead of abstract ornament, the geometric frames are filled with fairly realistic renderings of a lighthouse, a boat, and a small boy making sandcastles.

Another Anglo-Japanesque paper features New York and American sites (fig. 58). The Brooklyn Bridge, Niagara Falls, and an amusement park—possibly Coney Island—are shown. The Brooklyn Bridge, designed by John Roebling and constructed between 1867 and 1883, was the longest suspension bridge in the world. It became the subject of many paintings, photographs, and etchings. Interestingly, Roebling also designed a bridge at Niagara Falls (pictured) and a bridge over the Ohio River in Cincinnati (possibly pictured). These American vignettes are interspersed with pictures of oriental vases and backgrounds filled with flat ornament. It represents a bold and eccentric, but not atypical, marriage of American imagery and Japanese style.

Traditionalism
In the United States many newly minted millionaires were building palaces on Fifth Avenue in New York City as well as summer homes, which they called cottages, in Newport, Rhode Island. The walls of these mansions were covered with marble, tapestries, gilded leathers, carved wood paneling, and painted ornament, all meant to emulate European examples. By the 1890s architects who studied at the Ecole des Beaux-Arts in Paris were producing copies of French chateaus and Classical villas for their wealthy patrons and filling them with antique and reproduction furniture.

Sumptuous surfaces came into vogue, and wallpaper was produced to imitate gilded leather and tapestries. Flocking (the use of chopped fibers to add velvety texture) came into fashion. An American machine-printed paper from the end of the century depicts the subject matter and rich coloring of a tapestry (fig. 59). The timeless scene of European peasants and farmers enjoying the simple pleasures of nature may have been reassuring to Americans who saw their cities flooded with European immigrants.

Wallpaper had been used in the past to decorate ceilings, but during the last quarter of the nineteenth century, it became part of a total decorating scheme. The piece of ceiling paper shown here would have been used in the corners (fig. 60). The bands and stripes would have run the perimeter

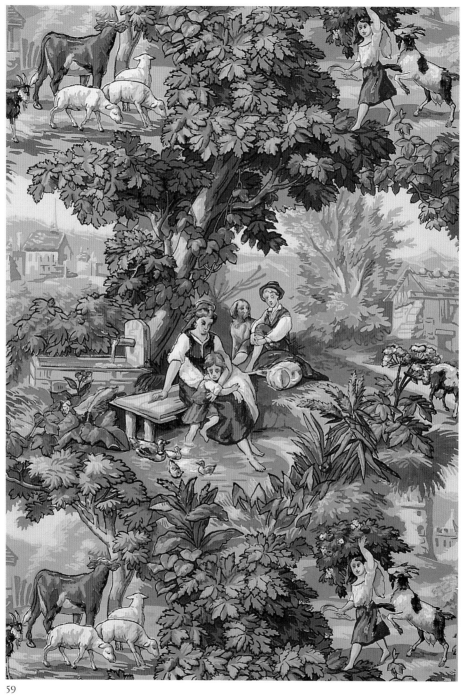

59

59

Pastoral vignettes with figures
United States, 1890–1900
Machine printed
79.5 × 48.0 cm
Gift of Harvey Smith,
1946–57–5–b

60

Ceiling border with water mill
United States, 1875–1900
Block printed and flocked
52 × 51 cm
Museum Purchase from
Smithsonian Institution,
1995–165–2

60

of the ceiling and offered the possibility of dividing the surface into smaller segments to be filled in with other designs. In a period of rapid change—electric lighting devised by Thomas Edison in 1880, the first car built by Henry Ford in 1893, and the invention of the motion picture by the Lumières in 1895—the old mill and cattails are immensely nostalgic. They recall the Barbizon painters' works from the middle of the century, which were still very popular in America. At the same time, the design reveals a sophistication in the way the image of the mill is treated as a picture, with one corner folded over and the cattails adding dimensionality by running over and under the "picture." By placing traditional landscape imagery within a modern compositional device, this wallpaper anticipates the two approaches to landscape wallpaper that dominate the twentieth century: a revival of romantic subject matter and modern abstraction.

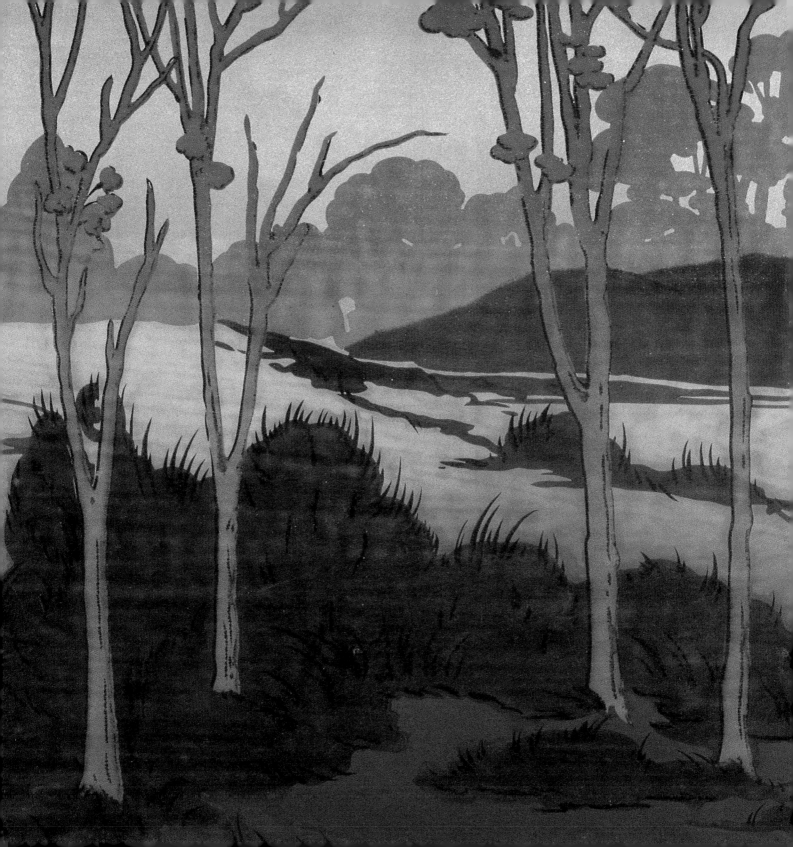

Chapter Four

Landscape Abstracted, 1900–1960

The twentieth century introduced an explosion of cultural changes and wallpaper styles. Machines economized production and speeded the pace of life, home ownership became common, and demand for consumer products intensified. The number of wallpaper manufacturers and retail outlets multiplied, and the range of papers offered diversified greatly. Landscape imagery assumed new meaning as more and more people moved to cities and suburbs, and farmland and forests disappeared in the process.

Arts and Crafts Friezes

By the 1890s, the complexity of three-part papers that included a frieze, dado, and sidewall, was left behind as consumers sought greater simplicity in interior design. Window treatments became lighter. Furniture—most notably Gustav Stickley's Mission pieces—became less ornate. Wallpapers followed suit, and many were produced in the Arts and Crafts style. This taste reflects the growing importance of American wallpaper manufacturers, because it was not until the turn of the century that the Arts and Crafts movement, begun decades earlier in England, became fashionable in the United States.

The preferred wall treatment in the Arts and Crafts style was a wooden wainscot or a plain wallpaper hung on the lower part of the wall, crowned by a patterned or pictorial frieze. Friezes often featured views of nature that evoke nostalgia for the preindustrial landscape, in the same way that the furniture and objects built by Arts and Crafts artists reach back to earlier aesthetic styles and methods of production. Many of these friezes reveal the influence of Japanese art, which continued to be an important source for painters and designers. In wallpaper design, this influence often took the form of cropped objects in the foreground, a flattened rendering of perspective, and asymmetry.

Opposite

Detail of figure 62

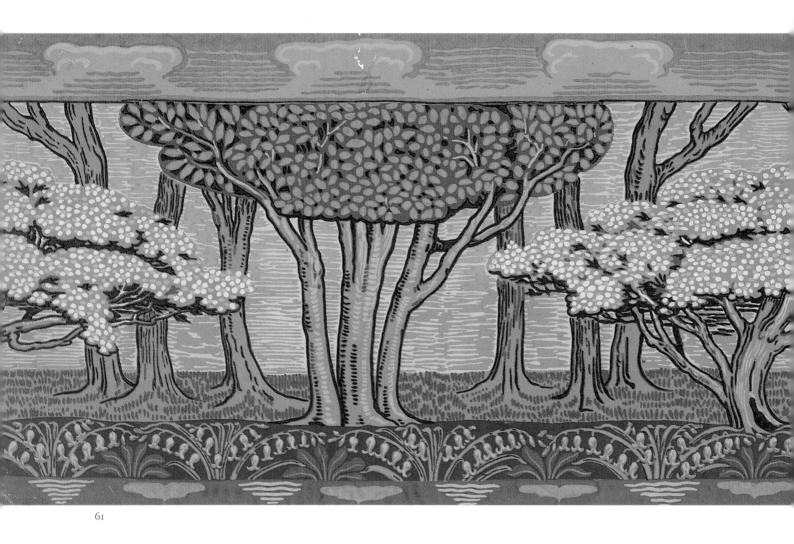

61

61

May Tree, frieze
England, 1896
Designed by Walter Crane
Printed by Jeffrey & Company
Block printed
57.5 × 137.0 cm
Gift of Roger Warner, 1955–144–7

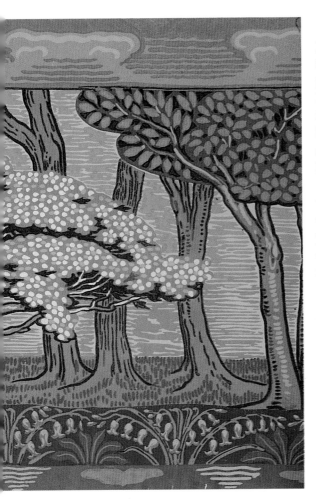

In *The May Tree*, the influences of the Arts and Crafts movement and Japanese art, can be readily discerned (fig. 61). Designed in 1896 by book illustrator and designer Walter Crane (1845–1915), this paper was hand-printed with woodblocks by Jeffrey and Company, who printed William Morris's papers. Crane has abstracted the sky into a band with clouds and flattened the lily of the valley plants on the woodland floor. The trees and blue background are modeled with straightforward wood-cutting tools and are heavily outlined, as were many elements in Japanese prints. The leaves are circles of color with no delineation.

Crane's wallpaper was expensive, designed to appeal to those customers with an understanding of Japanese design and modern art. The development of photography in the nineteenth century had obviated the painter's or illustrator's need to make realistic images. Early twentieth-century artists began to render the world in a highly interpretive, abstract fashion. Henri Matisse's sun-drenched Mediterranean scenes, Joan Miró's abstractions of rural life, and Wasily Kandinsky's visionary non-representational landscapes all express the power of natural forms while leaving literal realism behind.

With many fine and decorative artists no longer interested in realism, the landscapes on wallpapers from this period became pleasing compositions, relegated to the upper reaches of the wall. Although the abstractions seen on wallpapers were not as bold as those in painting, manufacturers were no longer producing the illusion that one was surrounded by a view. The landscape became a symbolic feature of a space—a romantic dream of the countryside reduced to trees and distant hills.

This trend was popularized by Arthur Wesley Dow (1857–1922), an influential teacher and artist whose aesthetic approach advocated Japanese design principles. Through his posts at the Museum of Fine Arts, Boston, Pratt Institute in Brooklyn, and Columbia University, and through his book *Composition: A Series of Exercises Selected from a New System of Art Education* (1899), which had twenty editions in print by 1938, Dow instructed his many students and followers to treat the landscape as a design to be interpreted and shaped rather than copied.

The frieze of an American paper from the early 1900s reflects Arthur Wesley Dow's influence in its abstracted trees, subtly shaded ground, and gold sky reminiscent of the gold-leaf backgrounds found on Japanese screens (fig. 62). This paper was machine printed, and then the nuances of the background were added by airbrush. A similar American frieze uses many of the same inspirations and elements—cropped trees and an

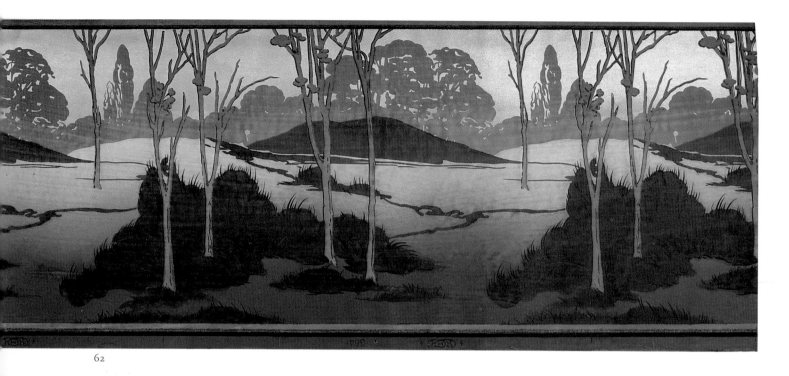

62

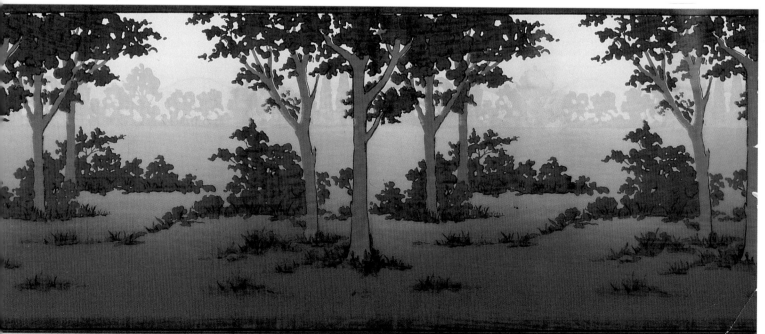

63

62

Frieze
United States, c. 1900
Produced by Hobbs, Benton &
Heath
Machine printed
51 × 121 cm
Gift of Paul F. Franco, 1938-50-16

63

Landscape frieze
United States, 1900-1905
Carey Brothers Wallpaper
Manufacturing Company
Machine printed
49.5 × 143.0 cm
Gift of Paul F. Franco,
1938-50-17-b

64

Frieze and sidewall from *Henry
Bosch Co.* sample book
United States, 1912
Machine printed
Gift of Marco Polo Stufano,
1992-127-1

65

The Oritani, frieze
United States, 1900-1910
William Campbell Wallpaper
Company
Machine printed
49.0 × 94.5 cm
Gift of Paul F. Franco,
1938-50-14-a

64

65

atmospheric background (fig. 63)—in a slightly more naturalistic color scheme and presentation.

In a page from a book of wallpaper samples, still another Arts and Crafts frieze of foreground trees with a subtle background is paired with its sidewall—a striped and shaded ingrain paper (fig 64). (An ingrain paper is one in which the color is added in the pulp stage of the papermaking process rather than simply printed on at the end.) The subtle color and texture of ingrains were a perfect complement to the pictorial friezes in this new period of simplified interior decoration.

In the early twentieth century the nostalgia for the preindustrial past led to a new interest in the Native American way of life and a new admiration for Native Americans' closeness to nature. By that time, the Native American population had been devastated, and most of those who remained were contained on reservations—changes that made it possible for their vanished customs and lifestyle to be safely romanticized by Americans. In *The Oritani*, a frieze from 1900–10 manufactured by the William Campbell Wallpaper Company in New York, Native Americans paddle canoes on a swampy river that resembles the Meadowlands in northern New Jersey (fig. 65). This paper renders the local landscape exotic by placing it in a historical context. The Oritani were, in fact, not a true tribe, but a group of Indians unique to the New York and New Jersey area. They were followers of Oratamin, a celebrated tribal leader from the 1660s of the Hackensack Indians in New Jersey.

Colonial Reproductions

The desire for a vanished way of life was also expressed in the early twentieth-century interest in eighteenth-century colonial buildings, furniture, and décor. The colonial revival had its roots in the Arts and Crafts movement. In the 1870s, William Morris founded the Society for the Protection of Ancient Buildings, which defended historic monuments from destruction. Concurrently in the United States the Centennial Exhibition of 1876, held in Philadelphia, awakened the public's interest in its early history.

One of the best marketers of this enthusiasm for the past was Wallace Nutting (1861–1941), who sold millions of nostalgic photographs and reproduced colonial furniture. He traveled the northeastern United States and photographed country lanes, rural homes, and other symbols of a disappearing agrarian economy. He also staged interior colonial scenes, and in *At the Fender*, the walls of a simple, early American room are covered in a scenic paper, Dufour's *Views of Italy* (fig. 66).

66

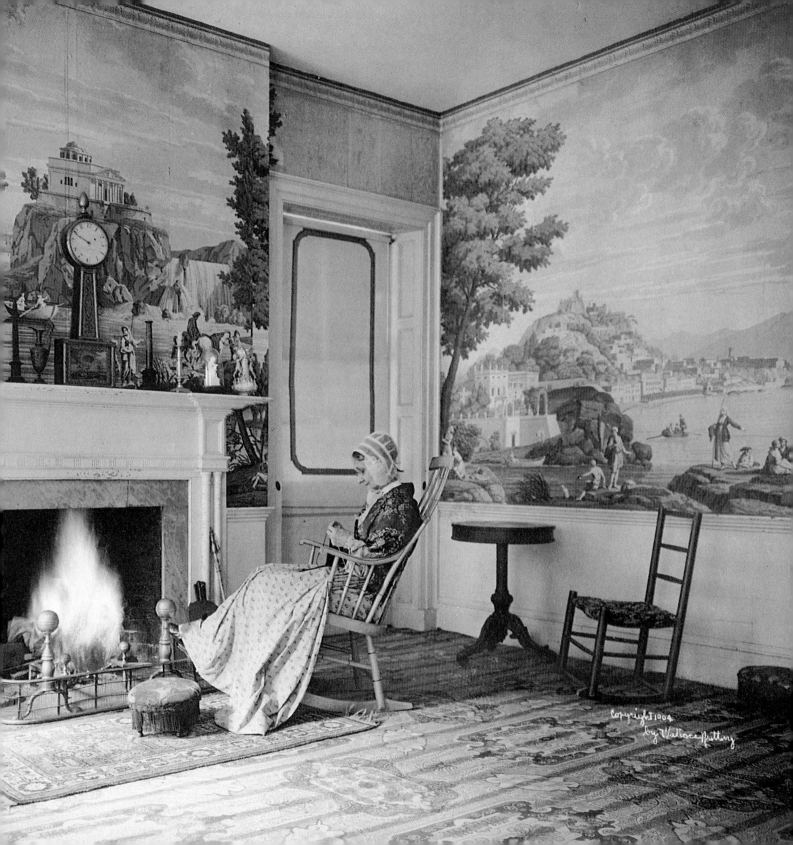

Copyright 1904
by Wallace Nutting

67

68

New homes were built in the colonial style, and their owners began to ask manufacturers for reproductions of appropriate wallpapers, including scenics. Thomas Strahan & Company, in Chelsea, Massachusetts, and Birge & Sons in Buffalo, New York, led the way in reviving papers that had first been produced between 1830 and 1850. Strahan printed *The Champlain* around 1915 (fig. 67), but the design is directly copied from a French paper produced around 1840.

During this period, homes of American heroes were restored and opened as museums, which generated a new need for historical papers. The Paul Revere Memorial Association, formed in 1905 to preserve Revere's Boston home and open it as a memorial, asked Strahan to manufacture a reproduction paper originally used in the house. Birge & Sons created a landscape paper, which they entitled *The Roosevelt,* to be used for the nursery in the restoration of the boyhood home of President Theodore Roosevelt, a noted outdoorsman (fig. 68). In *The Roosevelt* vignettes of fig-

69

ures outdoors near villages or large country homes are separated by natural devices, such as tree branches and worn footpaths. Papers such as this one remained in vogue until the 1950s. Part of their appeal was their connection to a historic site, style, or person. Both Strahan and Birge named their papers with this selling point in mind—*Louis XV, The Lucerne, The Deerfield,* and *The Nathaniel Hawthorne* were among their offerings.

A smaller-scale scenic, *Windsor Castle,* was newly designed in the historical mode by the British company Sanderson (fig. 69). The castle—glimpsed through a heavily wooded foreground, up a small stream, and beyond a stone bridge—is secondary to the surrounding landscape. This paper was introduced in England in 1912 and sold well until 1939. In 1952 it became available to the American market and sold for another sixteen years, indicating the strong market for historical and revival landscape papers throughout much of the twentieth century.

Another long-selling English wallpaper is *The Hawes,* in which a

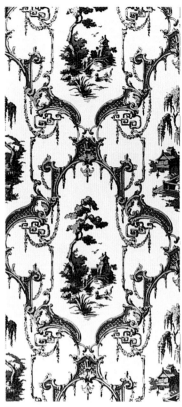

70

chinoiserie framework surrounds a conventional scene to create a dra-
matic effect (fig. 70). Introduced in 1919, this paper was in production
until 1946. In addition to the color scheme shown here, it was also avail-
able as an imitation of Chinese lacquer, printed in red and gold on a black
ground.

One of the most important promoters of historical wallpapers in the
United States was Nancy V. McClelland (1877–1959). An interior designer
and author who founded a decorating and antique business in New York
City in 1922, she sold antique scenic papers and produced a line of block-
printed reproduction papers, which were printed in France. She also pub-
lished *Historical Wall-Papers, From their Inception to the Introduction of
Machinery* in 1924, which remained the chief reference on the subject for
many years. Today, small- and large-scale scenic landscape papers can be
found primarily in historic house museums and restored private homes.

The Hawes
England, 1946
Designed by Henry Butler
Block printed
114 × 57 cm
Gift of Ross J. Dirksen, 1947–72–2

71

Wallpaper with military motifs
France, 1923
Designed by Jean Lurçat for Pierre
Chareau
Block printed
51 × 48 cm
Gift of Mrs. Cornelius Sullivan,
1930–21–1–f

71

However, the explosion of wallpaper production in the early twentieth century allowed many diverse styles to flourish simultaneously. As some customers looked to the past, others had their eyes on the future.

Modernism

The increased abstraction seen in paintings of the 1900s and 1910s had, by the 1920s, made its way into the decorative arts. Wallpaper manufacturers throughout Europe and the United States created designs to satisfy a new avant-garde sensibility. Simple forms and bright colors appear in a French paper from 1923 (fig. 71). Conceived by tapestry designer Jean Lurçat and produced for architect Pierre Chareau, it depicts an abstracted landscape with cliffs, water, and small villages inside a frame of large palm fronds. Despite the fact that the paper was displayed in a child's nursery at the 1923 Salon des Artistes Décorateurs in Paris, such

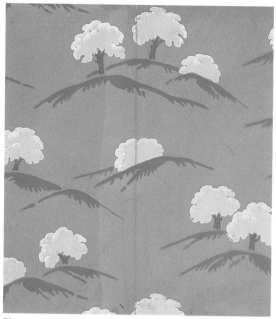

72

73

72

Mariza
Vienna, Austria, 1926
Designed by Maria Likarz
(1893–1971)
Produced by Flammersheim and
Steinmann
Machine printed
92.5 × 74.5 cm
Gift of Dr. Francis Geck,
1980–73–12

73

Abstract landscape with trees
Probably France, 1928–30
Machine printed
48 × 48 cm
Gift of Charles Grimmer and Son,
1930–14–1–e

74

Tree and Cow
England, 1927
Designed by Edward Bawden
(1903–1989)
Lithograph from linocut
55.5 × 55.5 cm
Museum purchase from
Smithsonian Institution
Collections Acquisition Program
and Pauline C. Noyes Funds,
1996–32–2

elements as a Citroën tank, a large battleship, a hot-air balloon, and an airplane may refer to the recently ended World War I.

A paper entitled *Mariza* from 1926, created for the influential Wiener Werkstätte (Arts and Crafts Workshop in Vienna), shows an abstract landscape with virtually no depth (fig. 72). It reveals the influence of the overlapping planar forms of Cubism, the strong colors of the Ballets Russes, and the elegance of Viennese decorative arts.

A dramatically colored but simply designed landscape of trees and hills is featured in a paper from the late 1920s (fig. 73). The landscape, no longer representational, has become purely decorative. It suggests the growing sophistication of the public, as people moved to cities and as museums, galleries, and popular art magazines—such as *The Studio*, *Art et Décoration*, and *Deutsche Kunst und Decoration*—became more common.

Some artisans continued to print wallpapers by hand, continuing the principles of the Arts and Crafts movement while designing more modern interpretations of nature. Edward Bawden (1903–1989), an English book illustrator, printmaker, and painter, was inspired by William Morris's paper *Daisy* to design his own wallpapers. *Tree and Cow* (fig. 74) was created by carving a design onto linoleum blocks and printing it by

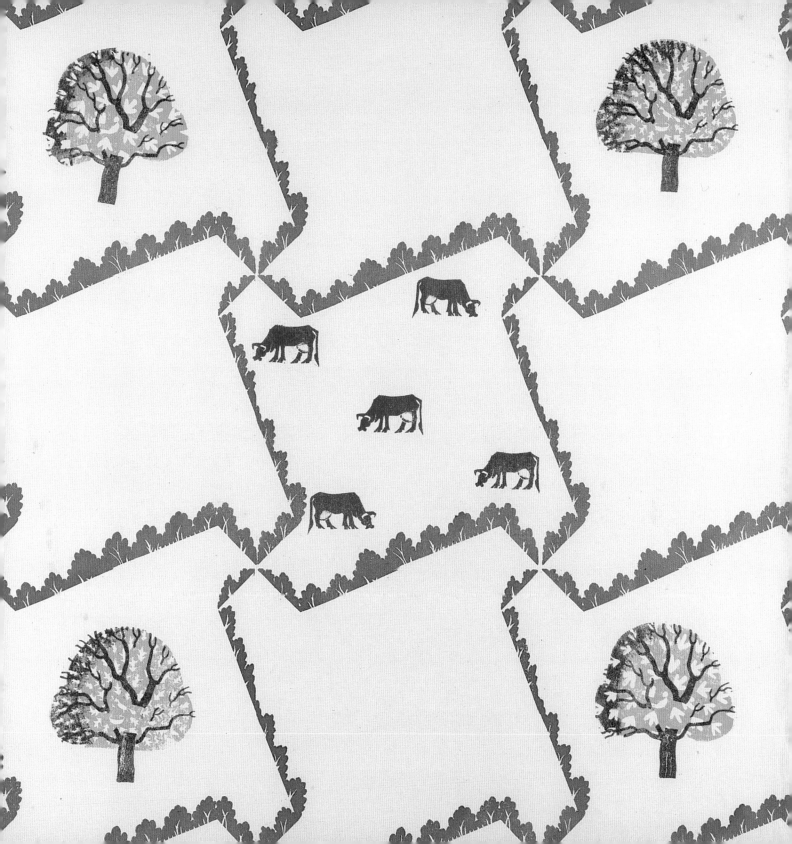

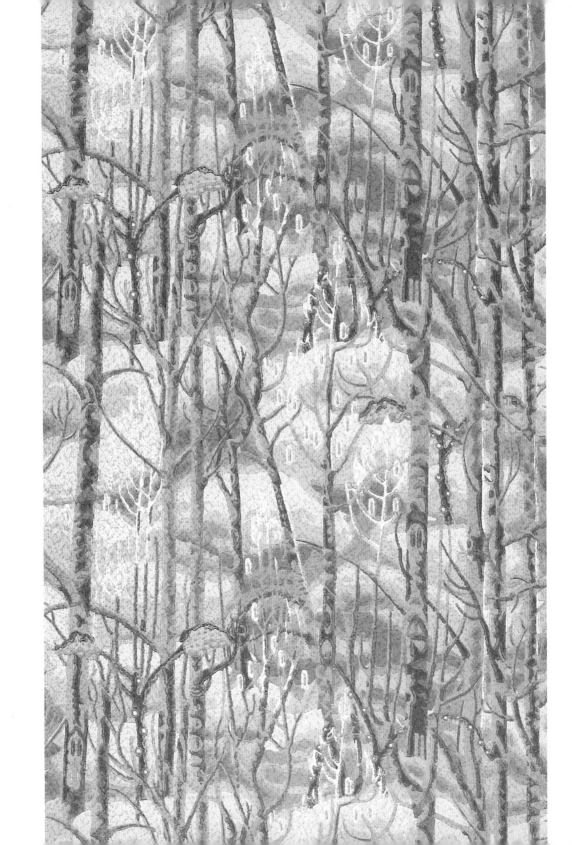

75

The Birches
Buffalo, New York, 1921
Designed by Charles Burchfield
(1893–1967)
Produced by M. H. Birge & Sons
Co.
Machine printed
80.5 × 50.5 cm
Gift of Mrs. Edna Lindemann,
1992–109–1

76

Landscape vignettes and abstract
multicolor rectangles on a stylized
cloud background
Probably United States, c. 1935
Machine printed
101 × 49 cm
Gift of Robert L. and Jean L.
Thompson, 1992–157–11

76

hand on single sheets. This format made Bawden's papers difficult to hang, and they became popular only after World War II, when they were issued as standard rolls. Bawden's simple, graphic representation of a pastoral landscape conveys traditional subject matter in a thoroughly modern language.

Bawden was certainly not the only fine artist designing wallpaper at this time. Charles Burchfield (1893–1967), an American painter known for his ghostly but lyrical watercolor landscapes, designed papers for the Birge company, beginning in 1921. He based one of his earliest designs, *The Birches* (fig. 75), on his painting *Bluebird and Cottonwoods* (1917). Available in brown or gray, *The Birches* depicts leafless trees set against mounds of snow or rocks, depending on the colorway.

A less painterly landscape paper by an unknown designer mixes puffy clouds, two tiny country houses, and floating marble or linoleum squares (fig. 76). A pastiche of traditional and modern subject matter, this paper may have been designed to appeal to an audience not quite ready to embrace modernism. Produced during the Great Depression, papers such as this one were an inexpensive way for people to bring their homes up to date. The economic realities of the period created a cautious approach to designing new patterns—an attitude that only intensified during World War II, when the production of wallpaper, and most other consumer goods, was disrupted.

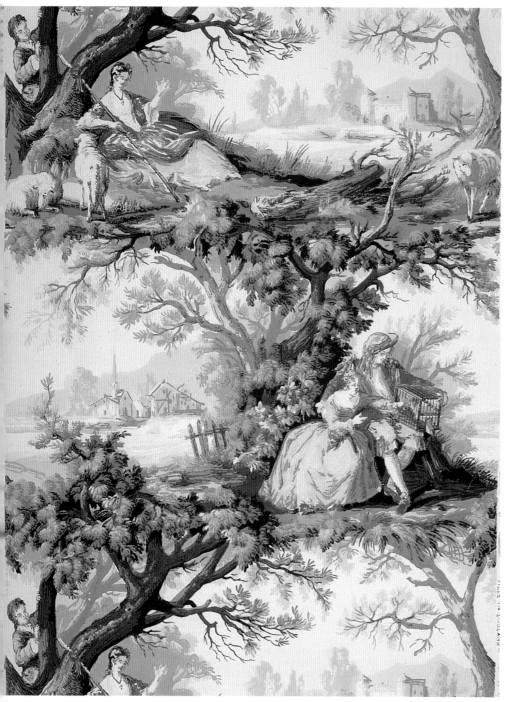

77

78

77

Shepherdess with sheep
England, 1945
Produced by Crown Wallcoverings
Machine printed
81 × 56 cm
Gift of Ross J. Dirksen, 1947–72–1

78

Tree-framed scene
Hanover, Pennsylvania, 1945–58
Produced by Eisenhart Wall Paper
Company
Machine printed
102.5 × 49 cm
Gift of Suzanne Lipschutz,
1991–89–145

Peacetime Vistas

In the boom economy of postwar America, many new designs were introduced to meet the decorating demands of an unprecedented number of homeowners. Traditional landscape papers continued to compete with more modern interpretations. The *fête galante* style so popular in the eighteenth century reappears in a new English paper of the mid-1940s (fig. 77). The bucolic countryside is treated as a carefree playground as consumers sought escape from the harsh realities they had so recently endured. The appeal of historical representations of landscape is understandable given the bomb-torn state of Europe at this time. Many postwar European papers were intended for export, often to the United States, as a way of generating income with which to rebuild wallpaper's manufacturing plants and its national market.

Americans were also interested in traditional design. The Eisenhart Company presents an equally idealized and serene, unpeopled landscape drawn in a naturalistic fashion (fig. 78). Postwar American homebuilders and designers were offering new ways to bring nature indoors. Patios, picture windows, and wood-paneled or stone walls, as well as wallpapers with imitative natural textures, including real grasscloth, were ubiquitous features in new suburban tract homes. Another concurrent innovation was wallpaper designed to be hung on just one wall of a room, and many of these papers featured landscapes to provide the illusion of a view where none existed. This paper would most likely have been used in this manner.

Simplified, abstracted landscapes were another way to create a view indoors. The agricultural lifestyle, which was rapidly disappearing across the U.S. as cities grew and suburbs exploded, is glorified in a paper from the late 1940s (fig. 79). Farm women toil in the fields as deer cavort nearby. In another American paper from a decade later the landscape is rendered more atmospherically (fig. 80). Inhabited land in the form of small fishing villages represents pockets of civilization within the larger, uncultivated landscape.

The California lifestyle—with its emphasis on informality and indoor-outdoor living—came to epitomize the good life for many Americans in the 1950s. Capturing this new fascination is a paper that celebrates traditional California architecture with newer style homes (fig. 81). The houses are situated next to mountains and ocean, suggesting a domestic lifestyle thoroughly integrated with nature.

A dramatic way to transform living space was the photo mural—a huge reproduction of a photograph (first available in monochrome and later in

79

Stylized landscape with deer and figures
United States, 1946
Devoe and Raynolds Company, Inc.
Machine printed
55 × 41 cm
Gift of George H. Fitch,
1949–88–2–m

80

Gray landscape with red buildings
Possibly United States, 1955–59
Machine printed
195.0 × 51.5 cm
Gift of Diane Price, 1998–7–1

79

80

81

California Villas
United States, 1954
Produced by Griffon-Sefton, Inc.
Machine printed
139 × 56 cm
Gift of Suzanne Lipschutz,
1991–89–227
Photo by Ken Pelka

82

Jackson Lake photo mural
Page from sample book,
Backgrounds for Better Living
United States, 1948
Foto Murals of California
Gift of Various Donors, 1980–78–1

82

full color) that filled one wall and created the illusion of a large picture window and a majestic vista beyond. Although they had been introduced in the 1930s by such notable photographers as Margaret Bourke-White, Edward Steichen, and Ansel Adams, photo murals did not take off commercially until the 1950s. Celebrating the most sublime landscapes in the world, they allowed a person to sit in a suburban living room, and look out on a "tropical paradise."

In *Jackson Lake*, the view is of Grand Teton National Park with window mullions printed directly on the paper (fig. 82). This attempt at "realism" or trompe l'oeil is especially odd juxtaposed against a view that was available only in black-and-white or sepia tone. In the sample book promoting this paper, the manufacturer highlights the appeal of this new medium for the most contemporary interior styles by showing it in a living room furnished with spare, modern pieces, including the quintessential Eames chair, first produced in 1946.

Photo enlargement was also used as a new technique to produce the most traditional landscape wallpapers. Manufacturers photographed prints of landscape paintings or French scenic papers to create new offerings.

Photo murals were just one way to dominate a room with a view on one wall. Large-scale landscapes were also produced through a process similar to blue-printing. An artist's rendering could be faithfully reproduced either positively (dark lines on a light ground) or negatively (white lines on a dark ground) in a variety of color palettes. *Arches*, designed by Ilonka Karasz for

the New York firm of Katzenbach and Warren (fig. 83), alludes to the tradition of heroic landscapes—with its architectural structures among trees, plants, and animals.

Karasz, who was born in Hungary and emigrated to the United States in the 1920s, also designed a wallpaper that pays tribute to the landscape of her adopted country (fig. 84). *American Landscape* presents a colorful panorama in which Karasz employs her signature style of flattened motifs and very shallow perspective. Americana-themed landscape papers were also available from other manufacturers. As with photo murals and blueprint papers, this would have been hung on one wall to give the illusion of a view.

These large-scale, nonrepeating landscape papers from the 1950s harmoniously unite a modern aesthetic with a pastoral subject and a time-honored format. Although the romance of pastoral imagery would be overshadowed by abstraction in the 1960s, landscape papers in large formats endured.

83

Arches, page from sample book
United States, 1948
Designed by Ilonka Karasz
Produced by Katzenbach and
Warren, Inc.
Mezzotone print
Gift of Katzenbach and Warren,
Inc., 1959-134-1-17

84

American Landscape
United States, 1948
Designed by Ilonka Karasz
Produced by Katzenbach and
Warren, Inc.
Machine printed
Gift of Lanette Scheeline,
1998-29-66

83

84

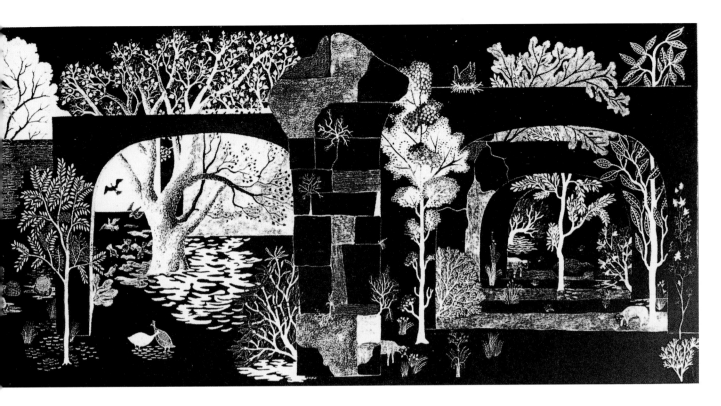

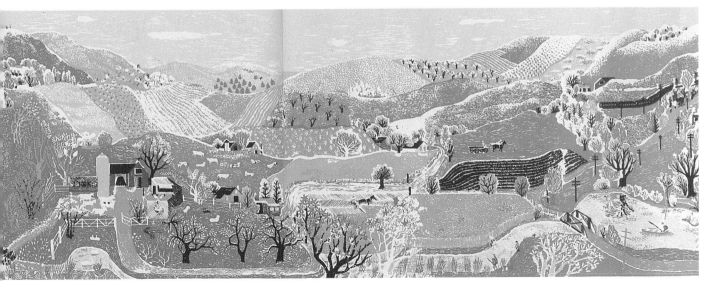

Epilogue

By the early 1960s, the postwar economic boom had become a global phenomenon, and consumer culture flourished, especially in Europe and the United States. The earliest wave of baby boom children reached adolescence around this time, and youth culture was born. Media outlets—in the form of magazines, television, and film—proliferated. With constant exposure to visual imagery and articles or stories about new trends, people became much more style-conscious. They began to define themselves by the clothes they wore, the films they saw, and the products they consumed. Manufacturers of those products—including wallpaper—quickly recognized the opportunity to produce items that catered to this new market, which embraced abstract pattern, bright colors, and new materials.

Many designers in this period came out of formal university design programs that had adopted Bauhaus principles such as the appreciation of flat, simple pattern and the belief that form should follow function. Europe's leading modernists had emigrated to the U.S. in the 1930s and 1940s and influenced the philosophy of American design education. Walter Gropius became a professor at Harvard, Mies van der Rohe headed the architecture department at the Illinois Institute of Technology, and Josef Albers established a design program at Black Mountain College.

As the gap between fine and commercial arts narrowed, each field began to borrow from the other. Andy Warhol created art with images of soup cans, and Yves Saint Laurent designed a dress to look like the paintings of Piet Mondriaan. All aspects of visual culture—including the landscape—were freely appropriated by artists and designers and then were commonly rendered as pure graphic elements.

In *Groves* (1960–67), designed by Ben Rose, a forest of trees is recognizable but gives no illusion of a view (fig. 85). These simple silhouetted

Opposite

Detail of figure 87

85

Groves
Chicago, Illinois, 1960–67
Designed by Ben Rose
Screen printed on vinyl
128.5 × 76.0 cm
Gift of Ben Rose, Inc.,
1969–104–5–b

86

On the Scene, from *Kaleidoscope,
Volume 1* sample book
United States, 1971
Screen printed
Produced by James Seeman
Studios, Inc.
Gift of Vincent Scalia, 1982–35–3

STRIP #1 STRIP #2 STRIP #3 STRIP #4 STRIP #5

On The Scene

THE SET CONSISTS OF 5 PANELS ONLY. EACH 28 INCHES WIDE AND 12 FEET HIGH. THE 5 DESIGN PANELS
WILL COVER 11 FEET 8 INCHES OF WALL SPACE. HIGHEST POINT OF DESIGN IS 80 INCHES WITH 32 INCHES OF GROUND PROVIDED
BENEATH THE DESIGN. PANELS #5 AND #1 CAN BE JOINED TO COVER LARGER WALL AREAS.
COPYRIGHT, 1971 JAMES SEEMAN STUDIOS, INC.

FOR ADJOINING WALLS WE SUGGEST:

PATTERN #JSK 1241

PLAIN VINYL #JSK 1407

86

87

Les Falaises (*The Cliffs*)
Rixheim, France, 1976
Designed by Alain Le Foll
(1934–1981)
Produced by Zuber et Cie
Screen printed
4 panels: 282 × 74 cm each
Gift of Zuber et Cie, 1989–26–1/4

shapes are cropped to form horizontal bands that balance the verticality of the trees. In Rose's hands, the landscape has become pure pattern.

By contrast, James Seeman's wallpaper mural *On the Scene* (1971), reduces a mountainscape to pure form and color (fig. 86). The title combines contemporary slang with an oblique reference to "scenery." While this nonrepeating paper would have filled one wall, the Zuber company created new panoramics that would fill a room.

Les Falaises (*The Cliffs*), from Zuber's *Landscapes* series of 1977, resurrects the form that they had mastered so beautifully in the nineteenth century and brings it thoroughly into the twentieth (fig. 87). Surrounding the viewer with subtly colored ancient rock strata, it works simultaneously as a landscape and a pattern. The form changes, but the inspiration remains the same.

In the twenty-first century, designers will no doubt continue to be inspired by the world around us. The land that we inhabit will become the subject of new patterns and wallpapers, which will be affected by the growing awareness that landscape and ecological systems are increasingly fragile. For perhaps the first time in centuries in the West, the human race is seen as part of nature rather than as observers and controllers of its domain. As culture continues to shape landscape, this sensibility will be reflected in the new ways we choose to represent nature on the walls of our homes.

Bibliography

Brown, Dona. *Inventing New England: Regional Tourism in the Nineteenth Century*. Washington, D.C.: Smithsonian Institution Press, 1995.

Clark, Kenneth. *Landscape into Art*. London: John Murray, 1949.

Clouzot, Henri. *Tableaux-Teintures de Dufour & Leroy*. Paris: Librairie des Arts Décoratifs, 1930.

Crandell, Gina. *Nature Pictorialized: "The View" in Landscape History*. Baltimore: Johns Hopkins University Press 1993.

Durant, Stuart. *Ornament: From the Industrial Revolution to Today*. Woodstock, N.Y.: Overlook Press, 1986.

Entwisle, E. A. *The Book of Wallpaper*. London: Arthur Barker, 1954.

———. *A Literary History of Wallpaper*. London: B. T. Batsford, 1960.

———. *Wallpapers of the Victorian Era*. Essex, England: F. Lewis, 1964.

———. *French Scenic Wallpapers 1800–1860*. Essex, England: F. Lewis, 1972.

Evans, Joan. *Pattern: A Study of Ornament in Western Europe from 1180–1900*. Oxford: Clarendon Press, 1931.

Frangiamore, Catherine Lynn. "Wallpapers Used in Nineteenth-Century America." *The Magazine Antiques*, vol. 102 (December 1972), 1042–51.

Gilpin, William. *Three Essays: On picturesque beauty; On picturesque travel; and On sketching landscape: to which is added a poem, On landscape painting*. London: Printed for R. Blamire, in the Strand, 1792.

Gombrich, Ernst Hans Josef. *The Sense of Order: A Study in the Psychology of Decorative Art*. Ithaca, N.Y.: Cornell University Press, 1978.

Hapgood, Marilyn Oliver. *Wallpaper and the Artist, From Dürer to Warhol*. New York: Abbeville Press, 1992.

Hoskins, Lesley, editor. *The Papered Wall*. London: Thames and Hudson Ltd., 1994.

Hussey, Christopher. *The Picturesque: Studies in a Point of View*. London and New York: G. P. Putnam's Sons, 1927.

Johns, Elizabeth, et al., eds. *New Worlds From Old: 19ᵗʰ Century Australian and American Landscapes*. Exhibition catalog. Canberra: National Gallery of Australia, 1998.

Katzenbach, Lois and William. *The Practical Book of American Wallpaper*. Philadelphia and New York: J. B. Lippincott Company, 1951.

Lewis, Philippa, and Darley, Gillian. *Dictionary of Ornament*. New York: Pantheon Books, 1986.

Lynn, Catherine. *Wallpaper in America: From the Seventeenth Century to World War I*. New York: W. W. Norton, 1980.

Manwaring, Elizabeth Wheeler. *Italian Landscape in Eighteenth Century England*. London: Frank Cass & Co., 1925.

McClelland, Nancy. *Historic Wall-Papers, From their Inception to the Introduction of Machinery*. Philadelphia: J. B. Lippincott Company, 1924.

Nouvel, Odile. *Wallpapers of France 1800–50*. New York: Rizzoli, 1981.

Nouvel-Kammerer, Odile. *Papiers Peints Panoramiques*. Paris: Musée des Arts Décoratifs and Flammarion, 1990.

Nylander, Richard C., Elizabeth Redmond, and Penny J. Sander. *Wallpaper in New England*. Boston: Society for the Preservation of New England Antiquities, 1986.

Nylander, Richard C. *Wallpapers for Historic Buildings*. 2nd edition. Washington, D.C.: Preservation Press, 1992.

Oman, Charles C., and Hamilton, Jean. *Wallpapers: An International History and Illustrated Survey*. New York: Harry N. Abrams, 1982.

Teynac, Françoise, Pierre Nolot, and Jean Denis Vivien. *Wallpaper: A History*. New York: Rizzoli, 1982.

Whitworth Art Gallery. *A Decorative Art: 19ᵗʰ Century Wallpapers in the Whitworth Art Gallery*. Manchester, England: Whitworth Art Gallery, 1985.

Woodham, Jonathan. *Twentieth-Century Ornament*. New York: Rizzoli, 1990.

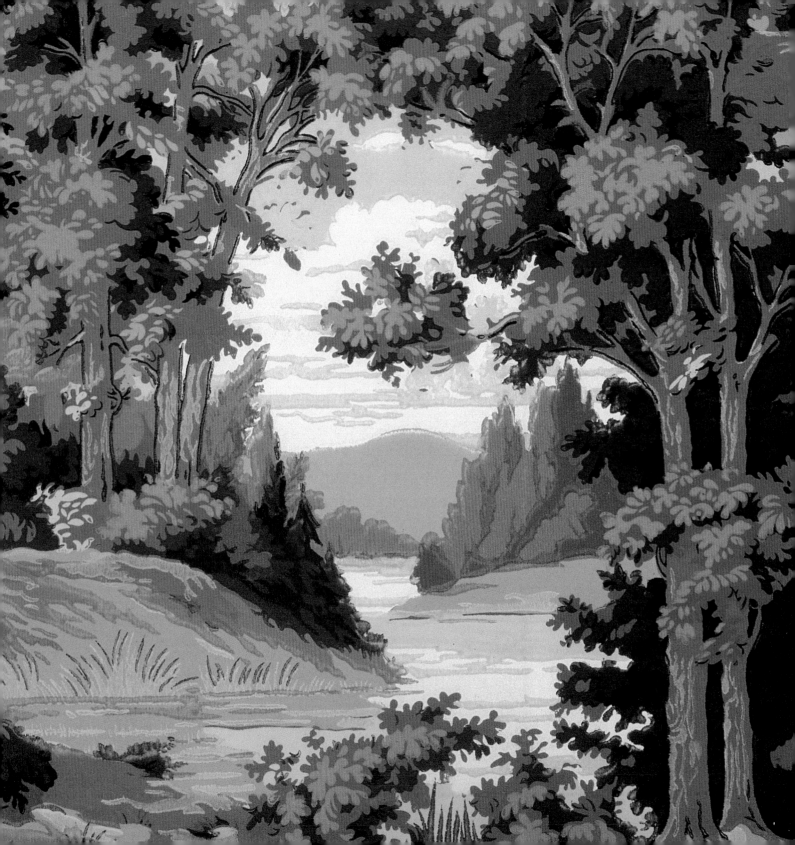